graphic design th

making the world intelligible

by
Peter Anderson
Patrick Roberts

edited
by
Richard Osborne

A history of graphic design begins with humans marking marks.

We start with an agreement that graphic design is the pursuit of human visual communication, which squarely places us in the caves at Lascuax, France with those atmospheric and enigmatic animal drawings. Representing things graphically then goes via the Egyptians, the Babylonians, the Greeks and the Romans, the medieval printers and then down to America. But Graphic Design as a subject really gets going in 1882 when William Addison Dwiggins (USA, book designer, typographer and illustrator) describes it as a confluence of related activities including book design, typography, illustration, lettering and calligraphy. Over the years the term began to stick. This term has become problematic today however as graphic design studios have responded to rapacious changes in technology and client demands leading to an enlarged role in the communication process. graphic design courses are often called 'visual communication' today to capture the changes.

The emergence of modern graphic design is umbilicaly connected to the development and advancement of the civilized world and it's cultural production, arts, technology, and finance. The first cave marks showed a human compulsion to record and interpret reality, modern graphic design discovered how to manipulate reality. However graphic design started to become significant when commerce recognised it's value and how it could be used to sell more products by creating styles and visual systems providing a differentiating commercial advantage. Advertising and graphic design are intimately connected, and this connection was first developed in America. Throughout the 20's & 30's in the USA a decorative deferential style is the default style of the day for print based advertising material and magazines. This classical style, essentially derived from Art Nouveau and aimed at impressing the reader, was already outdated by rapid social change. In Europe in 1910 we begin to see the reaction to decoration with AEG's Peter Behrens denouncing Art Nouveau in favour of sparse undecorated design. This is the incubator for the formation of the Bauhaus in 1919 committed to providing a 'no noodles' (Adolf Loos) approach to all design products. This stripping away of flowery decoration and movement towards the austerity of modernism can be attributed to the financial, political and personal catastrophe of World War I. When the Bauhaus opens it's doors in 1919 it was about to deliver one of the most influential turnarounds in design thinking of the century. Designers in Europe wanted a complete divorce from the historic visual traditions and hierarchical rules for the ordering of society which had brought about such calamitous events. Russian Constructivism began in a similar political crisis - the Russian Revolution of 1917. Rodchenko revolutionised graphic design paradigms using photomontage, angled type, simplified layouts and designs, reduced amounts of text, sans serif type faces and bold primary colour. The influence of constructivism can still be seen in work like the Franz Ferdinand record covers and posters and Sony playstation typefaces. After the first world war emigré designers escaping the political problems of Europe brought to America these new ideas about visual communication. The inter and post world war years brought an influx of 'modernist' architects, designers and artists escaping political and racial tyranny from Germany to the USA. Nazi Germany closed the Bauhaus in 1936 with it's teachers forced either to comply with "Volk's Art" or get out. Chicago and New York became the major centres and Alvin Lustig, Ladislav Sutnar in graphic design, Mies Van de Rohe in architecture and Josef Albers in design were very significant in radically influencing American products, advertising and print based design. And there was Jan Tschichold's 1932 seminal typographic treatise "Die Nue typography'(this is what is known as a seminal text). Nazism and Communism both enslaved visual design into the service of propaganda using Modernist visual language. What they were seeking to do is develop the language of persuasion and influence, a technique which was then utilised in corporate advertising and design. The long

consumer post-war boom, particularly in the USA, led to a period of compliant advertising dominated by corporations and limited experimentation. Eventually there had to be a reaction to the conformity of this consumerism. The 1960's psychedelia and pop art era was exactly this reaction: anti-corporate, anti establishment, and anti everything. The slogan of the day was 'Power to the People' and the visual art was anarchic, multi-coloured, high energy, individualistic, experimental and above all fun. Sex, free love, drugs, ,rock and roll, and anti-authority were the order of the day. Youth culture really came into it's own. The 60's was also a visual revolution. There is a "style" of the sixties that is instantly recognizable. Vinyl record covers of bands such as Love, Moby Grape, Ten years after, Jimi Hendrix, showed considerable contempt for rule based, rational, straight-jacketed cool modernist designs such as Paul Rand's IBM logo. These trends were heavily influenced by a resurgent interest in 'surrealism' in particular Salvador Dali and Rene Magritte's images of alienation and sexuality which were complete opposed to the rationalism of modernism. A major fracture developed between corporates and people in the 60's, an anti-consumerist revolution, which scared the living daylights out of the corporates. This is also the time of the Vietnam war with many Young Americans questioning everything - politics, civil rights, racial equality and patriarchy. Films such as Easy Rider, the Graduate and Blow up visually and politically reflected these changes. Eventually some of the more enlightened Corporates led by the Music industry found a way back into this revolution principally through the use of graphic design. Particularly in the USA where the designers of the sixties fringe and illegal magazine activities were enticed into providing toned down corporate friendly versions of their radical designs. Milton Glaser's PUSHPIN studio, Reid Miles designs for Blue note records evocatively fixed the visual language of the day. These American influences were also seen in the 'swing sixties' of ultra hip London, and to a much lesser extent in Europe. Throughout the 50's, and 60's 'modernism' was still the dominant design style movement and Germany were the major centre. Corporations still dominated the design culture. For example, Dieter Rams working as Braun AG's chief designer completely oversaw all aspects of the companies product and graphic design. The Braun company brand values were still about the implementation of 'form follows function', derived from Bauhaus ideas about design. The Swinging sixties percolated throughout the rest of Europe during the 70' and 80's. The visual and aesthetic battles of the post sixties period eventually led to a crisis in modernism and the emergence of 'post modernism'. Modernism had sought to impose a style which reflected a dominant and coherent aesthetic. Modernism had failed in it's historical promise to deliver health, beauty and a classless society.

Post Modernism is all about the fact there is no single visual style anymore. It's also about the fact that popular culture, mass media, high and low art, advertising and even the swinging 60's all become mixed up into one visual culture. Andy Warhol in his work showed how images, media, celebrity and communication had all became one. This was the post modern revolution. In another interesting development in the 80's, graphic designers such as April Grieman Katherine McCoy, Ellen Lupton, J Abbot Miller, P Scott Makela began to 'deconstruct' visual communication and produce completely new forms of visual language based on layering of type and image. This was aided by the advent of the Apple MAC and the introduction of Photoshop. These technological developments were vital to production of such 'deconstructed' images. The Cranbrook school of Design became synonymous with this approach. David Carson and Stefan Sagmiester take this process to it's final conclusion with Carson declaring 'the end of Print'. In this seminal book about type and image they argue that the audience develops their own meaning and reading, which is the cultural revolution. This is the advent of the digital revolution in which a globalised world and visual culture interact. This electronic democracy is undoubtedly transforming graphic design.

Graphic design is at the forefront of the 'communication of change'.

All new and radical products, services, and events employ Graphic designers to unveil,

explain, educate, and enlighten - defining its role *in making the world intelligible.*

Beginning with the fundamental particles of communication:

concepts and delivery media, **graphic design this way** defines and unfolds

their interaction, relationship and application within contemporary graphic design.

Covering key theories and practice of typography, semiology, systems

thinking and analysis, and production processes via concepts and media.

Secondly analyzing designers professional situations, in particular the role of

the designer within projects, marketing, client relationships, and professional practice.

Examples from both working professionals and design students show how their

thinking produced radical work for the time.

Finally bringing all these elements together into the applied commercial or

independent context.

Graphic Design is essentially concerned with visual communication.

As a reference point a simplified model of communication is used as a way of exploring graphic design throughout this book.

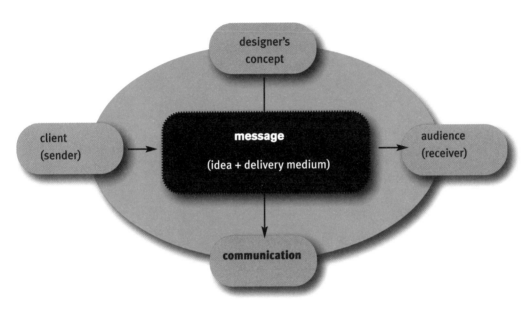

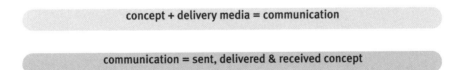

concept + delivery media = communication

communication = sent, delivered & received concept

a talks to **b**

company talks to **audience**

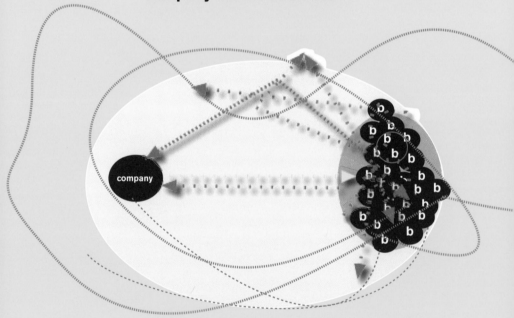

graphic design> some definitions

making the world intelligible
a way of thinking
making the world a better place
the confluence of science and art
problem solving
achieving a preferred solution
visual communication

Graphic design or visual communication is as old as the hills , particularly when you think of cave drawings as being the first form of human graphic design. Communication is one of the defining featurees of human advancement and a distinguishing mark of our species homo communicatus. The term graphic design first introduced by Dwight Wiggins in 1927 in the USA, and in England by Royal College of Art professor Richard Gyat. Originally Graphic design was 'design for the printed page' and as such many of it's rule and protocols derived from this heritage. All this changed with the advent of a do -it-yourself generation created by the digital revolution, new consumerism and a globalized postmodern viral culture. California was the hotspot creating and developing the digital revolution. Many elements came together at this point, diy graphics - the mac, the mouse, graphical user interface, quark xpress, illustrator, pagemaker, adobe's postscript, the laserwriter. This digital diy generation now had their hands on all the tools necessary to change the world or at least redesign it.

Graphic design was released into time and space and fixed outcomes such as print were no longer dominant. Designers had to think in different ways to respond to a new generation of multimodal delivery medias and audiences, but since designers have always been freethinking people this was not a problem. Print based design solutions became communications strategies where a central concept was played out across allmedia and new platforms. Designers recognised the importance of the emerging science of semiology, suddenly every component had layers and multitudinous meaning - polysemy. The major questions of the day now became the debate between individuality, such as David Carson and Stefan Sagmeister - the post modernists and formal design rule based client solutions such as Design Group North - the Swiss based rationalism or style versus neutrality.

Graphic design this way
presents a way of design thinking integrating all of these variables.

graphic design calculus - *getting into graphic design*

Graphic design is principally about visual communication. In truth the term 'Graphic Design' does little to capture the all encompassing current commercial landscape of professional activities for designers and communicators. However designers seem to be attached to the term graphic design rather than say 'information enviroment'. The changes we are considering can be seen simply both in the size of the industry, for example in London alone the creative industries have become the 2nd biggest employer, and in the endless complexity of forms of public communication.

If we accept that Graphic Design's primary aim is to communicate simple and complex messages effectively to a chosen audience then the first question to ask is, what are the controlling factors of communication. What are the determining factors, can they be rendered into a formula or proposition forming the very fundamental particles of communication operating as a unified theory for all communication in all places and at all times. This approach is the starting point for this book.

If we use a scientific or mathematical method to examine communication in it's generic form we can observe and identify certain essential elements which are always present in all communication.

We begin with the principle of 'the simplest solution tends to be the best one', which is based on Occam's razor - a principle attributed to the 14th-century English logician and Franciscan friar William of Ockham. This states that the explanation of any phenomenon should make as few assumptions as possible, eliminating those that make no difference in the observable predictions of the explanatory hypothesis or theory. The principle is often expressed in Latin as the lex parsimoniae ("law of parsimony" or "law of succinctness").

Lets take some familiar forms of communication -
a print ad - what you can say about the ad is that there is a message using the medium of print
a bus timetable - a message in the form of information and again it's printed and if you are lucky placed next to a bus stop
a film - again a message and delivered through the medium of film
a road sign - again a message and delivered through the medium of an aluminium plate in a public context
a web site - again a message and delivered through the medium of broadband, 3g produced by HTML or flash

we can quickly arrive at set of constants and a proposition that:

communication is a product of a message and an applied delivery medium or combination of media

so when a message + delivery media interact communication happens
or:

message + delivery media = communication

Closer inspection of the word message unveils a rather impoverished and unsatisfying way of describing that component. Concept would suggest a more precise, powerful and profound term.

How would we define concept? an idea/message in context. Context is a term or idea which we will deal with in great detail later on in this book.

So let's re-formulate and our new graphic design calculus becomes:

concepts
+
media
=

communication

or trying to make the world intelligible?

"Analogy and reminding whether they are accurate or not, guide all our thought patterns. Being attuned to vague resemblances is the hallmark of intelligence, for better or for worse".

"The clearest and cleanest statement of the problem that analogy poses is that there are always fights between forces pushing for literality (in its many forms) and forces pushing for abstraction (in its many forms)".

concepts

Metamagical Themes,
Questing for the Essence
of Mind and Pattern,
Douglas R Hofstadter

I was convinced that the line between reproduction tools and design would blur when information became electronic and that the lines between designer and artist, author and designer, professional and amateur would also dissolve."
Muriel Cooper Creative Code John Maeda

A picture is a fact
Ludwig Wittgenstein

image is an international language
Marjane Satrapi
Persepolis: The Story of Childhood

"It entered the visual vocabulary of photographers, painters and sculptors and focused on what pictures and words look like and what they can mean".
Barbara Kruger

contextualised ideas

bearers of meaning

propositions

enhancements

knowledge and experience

concepts

The inner core of visual communication, for all designers, is a concept.

As a starting point concepts can be broadly divisible into 6 main themes language, images, text and image relationships, organisation, media and sequences.
These divisions are a useful starting point and since human communication is very complex and sophisticated then designers will need to create concepts from combinations of these categories. Design is relational, relying on complex interactions between many elements, which are mutating and variable. It's important to point out why designers would start with a concept, rather than an idea The problem with ideas is they exist as abstracts, as ideal entities, whereas concepts exist within a real world context. Since all communication requires a context to be meaningful or make sense concepts are more powerful - they are above the constraints of language, they are applicable in all situations, and can work in all media.

the broad themes:

language (words)

image (pictures)

text and image (words and pictures)

organisational concepts

media concepts

sequential concepts

EXHUME TO CONSUM
BLASPHEMY MADE FLESH
ANCESTRAL NECROSODOMY
BIRTH BENEATH EART
SPIRITUAL AMPUTATIO
VOMITORIUM CONVULSION
OCCULT BLOOD EXCREMEN
TRIUMPHANT SECRETION
ENDLESS BLEEDING JOURNE
DIRTY INFAMOUS PAGAN FO
SUCK MY UNHOLY VOMI
MALIGNANT INCEPTIO
AWAKENED BY IMPURIT
DESTROY SACRED WORD

language as a concept

19

the future is bright the future is orange

just do it!

because you're worth it

I'm lovin it

the real thing

vorsprung durch technik

text, language and copylines

Language, Discourse and communication

Language results in similarities and the possibilities of agreement, and also in difference and disagreement. Language is also what distinguishes us from the apes. It is interesting to note that we call those individuals or groups who are savage or brutal, barbaric, which, etymologically, comes from the Greek barbarikós (those who go bar–bar–bar, related to the Sanskrit barbaras (stammering). In ancient Greek bárbaros meant 'those whose speech is unintelligible because they speak bar bar, that is, they do not speak Greek' – in a word, they are outsiders. We say that the meaning that one gives to a statement 'depends on where one is coming from', which is like the light bulb stories:

Q *How many psychotherapists are needed to change a light bulb?*

A *Only one, but the light bulb must want to change.*

In common usage 'to change a light bulb' means to replace it, but in a psychothera-peutic speech 'change' means emotional growth and development.

And for designers?

Q *How many designers are needed to change a light bulb?*

A *does it need to be a light bulb?*

The two sentences imply very different approaches: the first is a question anticipating a joke (there is a tradition about light bulb jokes), while the second comes from the design tradition, where the designer questions the framing of the brief - hence we laugh when we are confronted with the two possible readings.(polysemy)

So meaning it is not just about the specific words in a language but, because of poly-semy, the characteristic of words to have several meanings, it is about how they are shaped by their context. We differentiate between sets of meanings by calling them 'discourses'. When we wonder if we are speaking the same language we are actually wondering whether we share a discourse (the architecture), not just the lexicon (the bricks). Discourse is speech or writing seen from the point of view of the beliefs, val-ues and categories which it embodies, and these beliefs constitute a way of looking at the world, an organization or representation of experience – an 'ideology' in the neutral non-pejorative sense. Different modes of discourse encode different representations of experience. Discourse is the body of utterances, which give meaning or frame what is being spoken about.

Discourse - written or spoken communication or debate, more important
 in contemporary thought - a coherent set of ideas by which people live

the limits of my world are the limits of my language -

If, for instance, my chair were now to collapse, the meaning I would give to the event would be affected by the discourse I use to describe it. (Context produces meaning) The discourse I use will point to my beliefs and values, and those of my environment. If I were to speak from a discourse that is not meaningful within my context, my statement would not make sense, such as: the chair broke because today is Saturday. However, our discourse is not a conscious choice. We do not just speak through language but are also spoken by language. Some people talk about a discursive practice. A discursive practice is a body of beliefs enshrined in a discourse we use, eg Marxism, psychotherapy, design, science are all discursive practices. That is, their discourse determines and limits what can be constructed and thought. Because our reactions are in concordance with out context, they appear natural, but that is also quite a problematic term.

The tool box we have sets up the response that we will offer to the same problem, and it will seem natural to us, as it happens with culturally determined responses. Culture, however is not only about country of origin but about any culture, e.g., the culture of designers, where it seems natural to us to question the brief. This is not dependant on the words we have, because with knowledge of the same words we can devise very different constructs. We could refer to discourse as the set of unspoken rules that organize ones thinking about a subject. So I can consider the same event from different discourse, as in the example of the chair, and become aware that the speech or text I am confronted with comes from a particular perspective, such an environmentalist discourse, a political discourse, a feminist discourse. So a discourse, although it appears so, is not a reference to reality but to a reality. For instance, we may frame natural disasters and refer to them within an environmentalist discourse and we will argue for joining Friends of the Earth, or campaigning against the widespread use of 4x4 motorcars. Quite differently than if we address it from a humanitarian discourse and we will find ourselves proposing that action will be geared towards relief efforts. This is how we can identify when politicians use a rightwing or left wing discourse – there are key terms in a particular connection in either speech, which will signal their position. Or, childbirth, which has been long conceived within a medicalized view of women's health, as an illness requiring 'confinement' (the same word used to indicate the institutionalization of the insane) in hospitals, while the natural discourse has sought to integrate childbirth to the home and the family.

Accent and dialect also play a part as active indicators of the context defining the speaker.

Ludwig Wittgenstein

When I hear an utterance such as

- *I never done nothing (instead of 'I have not done anything wrong')*
 I immediately assume that the expression identifies the speaker's context.

Or, conversely

- *absolutely, old chap!*

Yet, class, age, and culture of origin are very ubiquitous. We will find that some of us (most of us?) share a particular (design) discourse in spite of wide differences in geographical culture, mother tongue, schooling, etc. So, discourse is an internal context, constructed by conscious beliefs and unconscious prejudices, and from which I speak and which shapes my thinking. And we have to remember again the concept of barbaric, that is, those who do not share my codes. Becoming aware of the discourse(s) be using, will allows us to consider the way we may be forced to think by the discourse(s), which are, in turn, using us.

(orginal text by carlos Sapochnik)

Discourse is like a language game you have to know the rules to play!

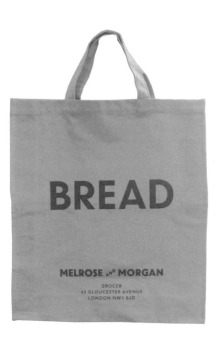

BREAD

MELROSE AND MORGAN

GROCER
42 GLOUCESTER AVENUE
LONDON NW1 8JD

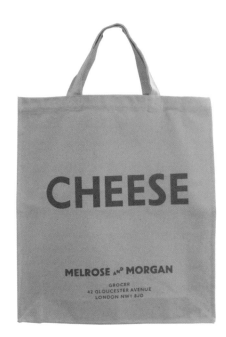

CHEESE

MELROSE AND MORGAN

GROCER
42 GLOUCESTER AVENUE
LONDON NW1 8JD

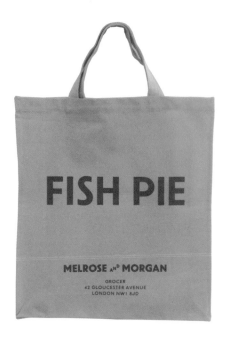

FISH PIE

MELROSE AND MORGAN

GROCER
42 GLOUCESTER AVENUE
LONDON NW1 8JD

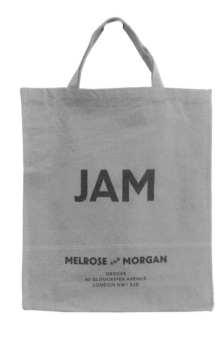

JAM

MELROSE AND MORGAN

GROCER
42 GLOUCESTER AVENUE
LONDON NW1 8JD

MELROSE ᴬᴺᴰ MORGAN

GROCER
42 GLOUCESTER AVENUE
LONDON NW1 8JD
020 7722 0011

JINGLE BELLS!

Christmas & New Year Opening Times
...
Christmas Eve
Sunday 24th December
8am—4pm
...
25th December—4th January
Closed
...

Design studio Kerr|Noble's concept
for Melrose and Morgan, an 'English grocer',
recognises the presence of the
'spoken language of the ordinary'
and devlops this into a synchonised visual langauge.

25

Bush on fire

nine people die in South Australian bush fire, Adelaide - Australia

... because not all news is local news

The Guardian Weekly

Lo in the Orient when the gracious light,
Lifts up his burning head, each under eye
Doth homage to his new appearing sight,
Serving with looks his sacred majesty,
And having climb'd the steep up heavenly hill,
Resembling strong youth in his middle age,
Yet mortal looks adore his beauty still,
Attending on his golden pilgrimage:
But when from high-most pitch with weary car,
Like feeble age he reeleth from the day,
The eyes ('fore duteous) now converted are
From his low tract and look another way:
So thou, thyself out-going in thy noon,
Unlook'd on diest unless thou get a son.

project *how to use language to generate concepts*

all shook up – constructing meaning – something from nothing

get a stopwatch set it for 15 minutes - press go
try to work out what these lyrics are from recent songs

> 1: tpuemDnshmo'coecoled gszl'heeto t
> 2: ninFL't Da I Doeikenel c
> 3: oouwnywehrye g une-
> 4: W Th hen ight e NM els ySonFe g
> 5: theebl womecdace to parl ak
> 6: te det ghod is ail in
> 7: f funollor m foctnwsio

make a note of the systems you use i.e. anagrams etc.
stop after 15 minutes - now you may have worked some of them out, but most likely
you have no idea and are really annoyed. We humans try to find a pattern when there
is none but there are systems we can apply.

Now you know there are no patterns what can you do?

Words don't naturally have a root to their meaning. The profound thing about
language is that we assign meaning to words. Take the example DOG. Dog has
no sound value resembling what a dog is but for whatever reasons in English we all
agree that a 4 legged hairy animal with a tail is a dog. The word does not refer to the
dogginess of the dog. Take this principle of applying meaning and use it to look at
the 7 dysfunctional phrases so that we can create meaning and syntax from seemingly
crazy arrangement of letters.
We will deal with this subject in more detail in the theory chapter later in the book.
The most important proposition we can put forward and apply in visual communication
is that meaning can be created or imposed on even our very strict rule based
language system. Language is after all our system and we can do what we like with
it providing every body agrees.! (Meaning is produced by consensus)
And providing we know the updated meanings or assigned meanings of words and
images we will make sense of the communication. Of course when we use a word
with an out of date meaning then all hell breaks loose. Take for example 'she's fit'.
This would translate to a person 30 years of age or older as somebody who uses
the gym regularly. However if you are under 20's you understand this very differently.

*brainstorm

project

take a simple sentence or phrase and write it out on a blank sheet of paper at the top
now rewrite the sentence or phrase without changing the meaning but using different
words. repeat this process 10, 20, 30 times. What becomes apparent is we now
have 30 new concepts because the subtle changes in nuance have occurred
which dramatically alter the meaning and lead to ...

example

the powers that be altered the mushrooms

the local authority made changes to the mushrooms

the chief cooked the fungi

project

The purpose of this exercise is to take familiar objects extract concepts and create
a name and visualise their look.

example

Object	function/context	name
Pen	controller/navigator	pilot
Telephone	personal broadcast system?	

Extract concepts from the following:

MP3. player	paper
building	hairstyle
break	car
shop	jacket
cyclotron	computer

having defined your object develop 20 names for each product

 **this is all semiotics which is all about how
language and images work in communication**

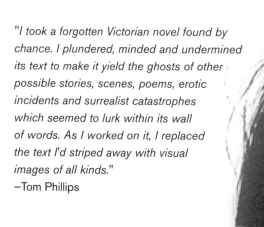

"*I took a forgotten Victorian novel found by chance. I plundered, minded and undermined its text to make it yield the ghosts of other possible stories, scenes, poems, erotic incidents and surrealist catastrophes which seemed to lurk within its wall of words. As I worked on it, I replaced the text I'd striped away with visual images of all kinds.*"
–Tom Phillips

BMW's 'the Ultimate driving machine' is implausible without the car's Image. The reverse cannot be said for the words.

image

Image based concepts are used a lot in visual
communication such as corporate identities, logos,
logotypes and emblems of a company or product,
and advertising campaigns. Images either illus-
trated or photographic were historically regarded
as secondary to text, partly because of
production costs but mainly because words
seemed more reliable. Text got overused and
the ercrowding of messages historically led to
a reaction. The arrival of digital systems dramati-
cally reduced the cost of reproduction and most
importantly the advent of television led visual
communication towards increasingly image based
work. .Comparing print ad's up to the 1960's with
ad's from 2007 show a major change. Text has
become very sparse, no longer 3 or 4 paragraphs
of text, and images have become the dominant
feature. Text doesn't allow you to own the product
but the image will and invariably the audience
wants to own the image not the words. Images
perform very different functions to text.
Art directors and designers priorise their reasons
for being there and their purpose. The text may
be the dominant element or the image may be
the main feature.

Given the need to communicate your message
as quickly as possible designers have come to rely
extensively on image based concepts. The right
image transcends the issues of language
because of speed of recognition and the places
where they are seen. Photography has profoundly
affected recent visual concepts. However for
a photograph to work it needs to be iconic order
to work in multitudinous contexts and media -
very small, very large, i.e. in all kinds of media.

Illustration, often commissioned by Art Editors
to 'pretty a page up' (David Blamey RCA),
provides a variety of meaning and fixings
but how can they be used as concepts or
how are concepts derived from images?

text as image - concrete poetry
At the beginning of the 20th century poetry was at the forefront of revolutionizing meaning particularly through the look and layout of the text. It experimented with not only the linguistic values and potency but also the visual, connecting words to the images. This became known as 'concrete poetry' and refers to innovations and experiments with typographic imagery

Two main centres of this new way of engaging with meaning emerged: in Europe with Swiss poet Eugen Gomringer and in Brazil the group NOIGANDRES.

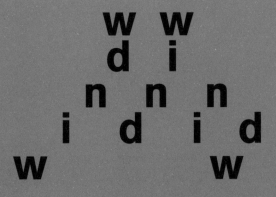

language become presentational
and participatory rather than
representational -
this is one of the major debates
and preoccupations of 20th
and 21st graphic design
either visual deference
or individual interpretation

text as image

A picture is a fact - Ludwig Wittgenstein

"Peter Anderson's organic typography can seem impenetrable. But he is not being difficult for the sake of it. As the reader learns new ways of reading, new possibilities for communication emerge"
Chris Forges, Blueprint

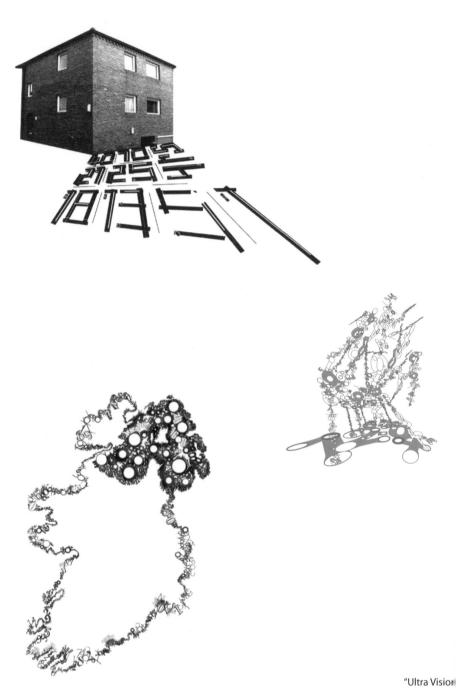

"Ultra Vision"
Worlwide Exhibition
Client: British Council
Design: Peter Anderson

atavirus"
dependant on Saturday Magazine
llenium Special Issue "Visions of the future",
ent: The Independant on Saturday Newspaper (Magazine)
esign: Peter Anderson Studio

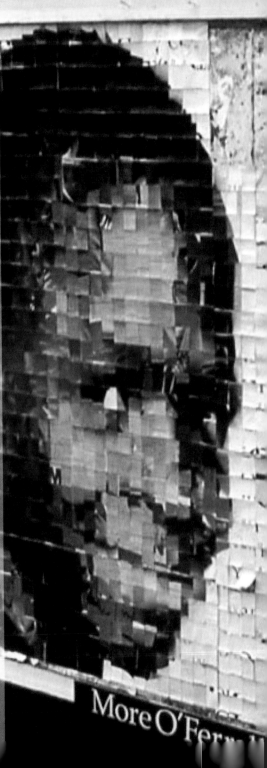

cut and paste

I've found that when preparing a page, I'll almost invariably dream that night something relating to this juxtaposition of word and image. In other words, I've been interested in precisely how word and image get around on very, very complex association lines.–
William S. Burroughs

'cut -up' is a method for distorting and discovering new realities in a text or image. The methodology is simple. For text, take lines and cut up the words or phrases put them in a hat, mix them up and pick them out at random and re-assemble them.

James Woodall's image began life as a 64 sheet poster for a chocolate bar. The poster was taken into a studio, meticulously cut up into small rectangles and re-assembled into a portrait of Damilola Taylor - a young boy murdered on a housing estate in South London, then replaced on the original billboard site.
'cut-up' technique has had a profound effect on all forms of communication and been employed by designers, artists, writers and musicians such as Thom Yorke, for "kid', David Bowie's 'Aladinsane' and William Burroughs' 'Naked Lunch'.
Muscians, Architects and town planners have use this randomization process to explore the possibility of improbability and unexpected out-comes, working against the flow.

More O'Fer

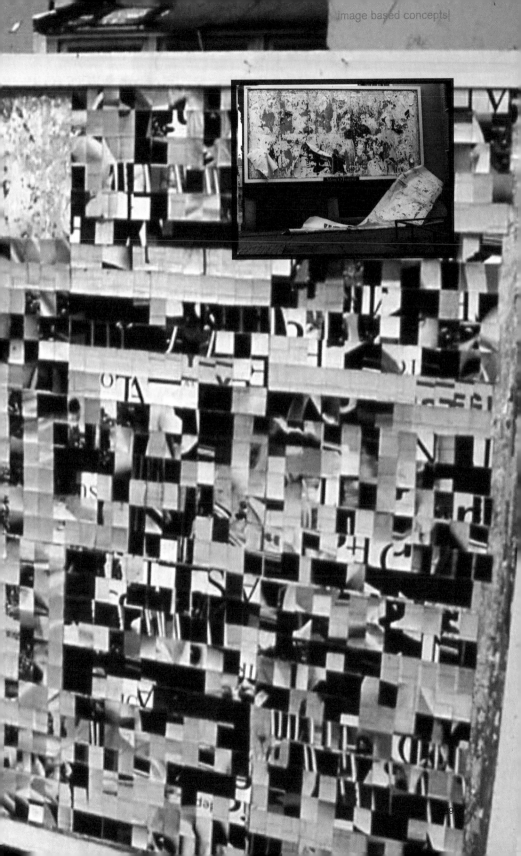

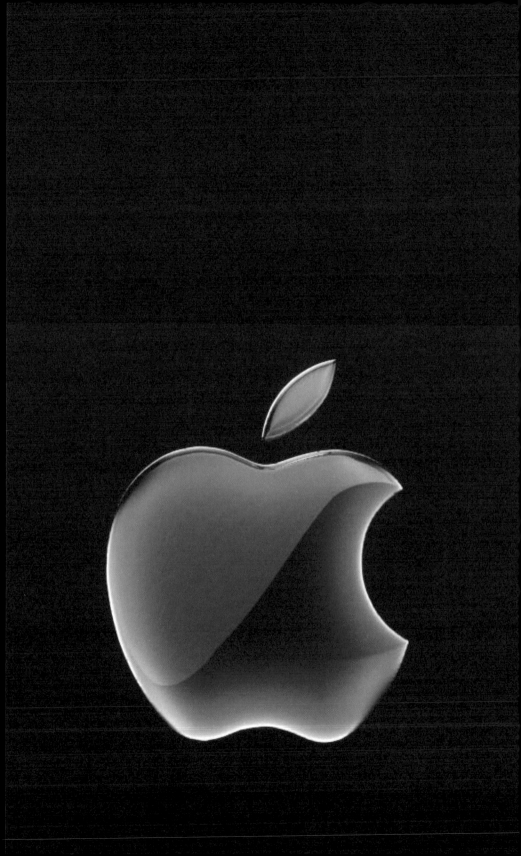

logos - how graphic based images are used as concepts for the aspiration of companies and their brand values.

Companies and brands have identities, just like people. This is because they have individual ways of behaving and communicating and, like people, if the company or brand behaves out of character the customer can be left feeling confused.

Companies and brands need to project their character very clearly. They do not want to confuse anyone inside or outside the organisation because an identity that's unclear is less likely to be attractive and so less likely to help us be successful.

Coca Cola, Sainsbury's, Orange and Virgin are examples of major companies seen and known, in some cases, all over the world but using a text and image arrangement. Apple's logo is pure image - no words are necessary now. In it's first incarnation the logo followed the traditional path of having the company name underneath the symbol. Fast forward 25 years and the image is all that is necessary. Instantly recognisable because each has a strong identity. This is no accident. These companies manage their identities very carefully. To do this they have regard for certain guidelines regarding the quality and appearance of their image.

The apple logo started life as a 'Lord of the Rings' like wood engraving with Isaac Newton sitting under a tree. It was then redesigned into the Rainbow logo by Rob Janoff and was used extensively until 1998 when the single colour was introduced and the name Apple dropped from it's implementation.

Feel warm and fuzzy.

Unlimited calls between four people on Vodafone Family.

Make the most of now

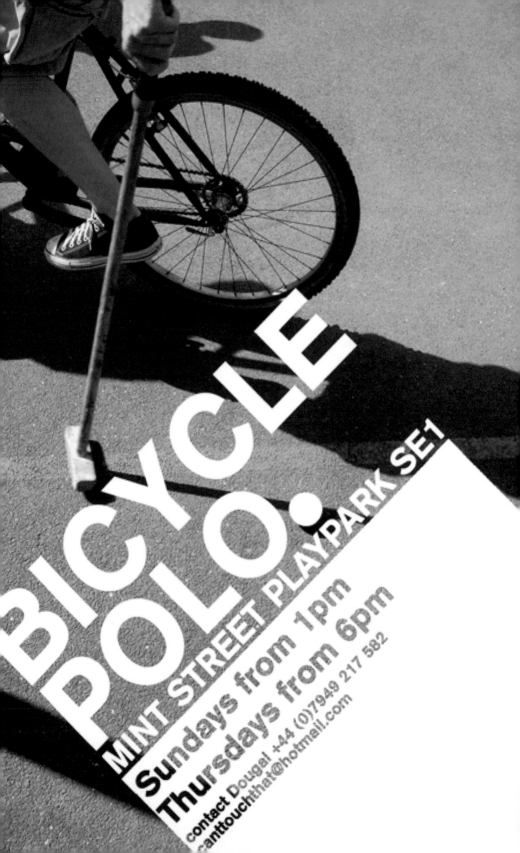

BICYCLE POLO.

MINT STREET PLAYPARK SE1

Sundays from 1pm
Thursdays from 6pm

contact Dougal +44 (0)7949 217 582
canttouchthat@hotmail.com

words and pictures

A potent force in any communicators's arsenal is the interaction of words and pictures otherwise called text and image. However what we aim to do is to establish some guiding principles for theorising and apllying this relationship.

In a contemporary context it is rare to see images used exclusively as the central communication concept. Although Benetton's **Colours** magazine published a whole magazine without words here the concept was the image.

The main thesis of how words and pictures interact and create meaning is based on Roland Barthes concept of anchorage. Barthes states that anchorage is a text (such as a caption) providing a linkage between the image and its context; the text that secures relevance to the reader. The term was introduced by Roland Barthes (1977). "It is a very common practice for the captions to news photographs to tell us, in words, exactly how the subject's expression ought to be read". Hall. This is a key aspect of the construction of text and image concepts such as advertisements.

Barthes introduced the idea of anchorage along with that of Relay, which is a recipro-cal relation between text and picture, in that each contributes its own part of the over-all message. It also relates a sequence of pictures to each other. This technique is typically how comic-strip frames move from one to the next, but is rarely used in adver-tising. If you do find any advertisements that have several panes or frames with some obvious transitioning from one to the next, you have found a good example of relay.

When you see a complete advertisement, you get a certain kind of meaning for the image, within the overall context that the advertisement provides. It may seem as though the image was "made for" that particular advertisement. However, a moment's thought will let you realize that, to a certain extent, any image can have any meaning . The text of an advertisement is primarily the extra information that guides the reader to a particular interpretation of the whole, and thereby a particular interpretation of the image (in other words anchorage).

political hystories

*f*eminist *r*eview | *85*

project

Part 1
First find an image without any text. Then identify the iconic messages found within it (all the possible meanings of the image).

Then in a separate piece, find or create a text identifying one of the possible meanings of your image.

Part 2
Starting from scratch, find or create a new image, and then produce a text that acts as relay, anchorage or both for the message of your image.

Part 3
Using these elements and ideas, create a poster with both text and image. Other than this, there are no restrictions to how your poster should look or be presented, however you should pay careful consideration to the composition of your piece. Too formal and it will fail to draw attention, too wild and you risk failing to communicate a message at all.

project - word chain

Part 1

Think of an event then imagine an object or detail which relates to this event. Write the first word which comes to mind.

Assign 2 hours to produce a chain of ideas which relate to this word.

Part 1

Now as quickly as you can find the shortest combination of words (or links) which connect your original word to your final word.

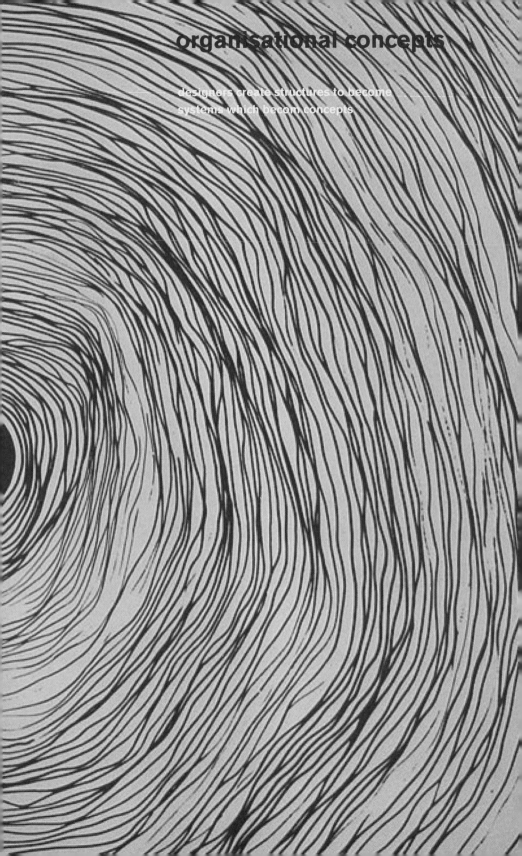

organisational concepts

designers create structures to become
systems which becom concepts

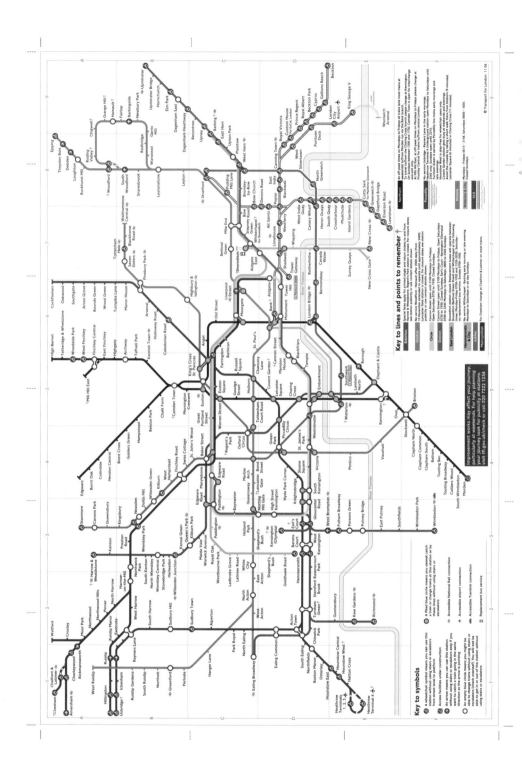

50

mapping

definitions

1 Mapping is making pictures of visual systems

2 mapping is the systematic set of correspondences that exist between constituent elements of the source and the target domain. Many elements of target concepts come from source domains and are not preexisting. To know a conceptual metaphor is to know the set of mappings that applies to a given source-target pairing. There are two main roles for the conceptual domains posited in conceptual metaphors:
 * source domain: the conceptual domain from which we draw metaphorical expressions.
 * target domain: the conceptual domain that we try to understand.

2 a visual representation of a place and its dynamics on a plane surface by means of linkage
 * to create a system with a set of elements in one-to-one correspondence with elements of an other set drawn from reality according to positions and relative distances in space and time

3 the organisation, classification of data determined and derived by pre-ordered parameters, such as time, metrics, rendered into a visual system

Frank Beck's famous tube map

Prior to the Beck diagram, the various underground lines were represented geographically, in the way a road map is. This had the feature that centrally located stations were very close together, and the out of town stations were spaced apart. From around 1908 a new type of 'map' appeared inside the train cars; it was a non-geographic diagram, in most cases a simple straight horizontal line, which equalized the distances between stations and made it easier to understand.

Beck who had the idea of creating a full system map in colour, believing that passengers riding the trains weren't too bothered about the geographical accuracy, but were more interested in how to get from one station to another, and where to change. Thus he drew his famous diagram, looking more like an electrical diagram than a true map, on which all the stations were more or less equally spaced.

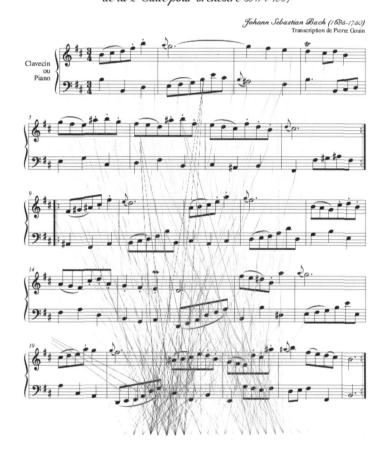

Menuet

de la 2e Suite pour orchestre BWV 1067

Johann Sebastian Bach (1685-1750)
Transcription de Pierre Gouin

Clavecin
ou
Piano

1st year Design student Katy Scott drew lines from all the notes in Bach's Menuet to the corresponding points on the keyboard. Red lines represent the notes played by the right hand, blue lines represent the left hand.

You can see how few keys out of the 85 keys on the keyboard are actually used, which is surprising as this piece has a very rich sound.,,interesting! The bar chart bits are to show exactly how many times each note is played. Today I will ink up my fingers and play the piece on my wonderful hand drawn keyboard (last picture) and make a fingerprint map, and need to start thinking about a metaphorical map....

mapping

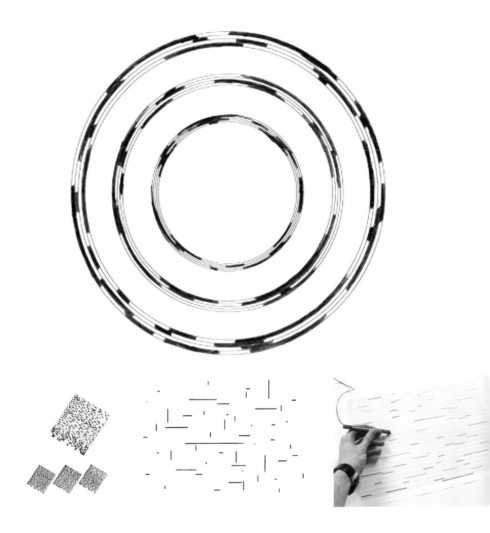

Simon Elvins: NOTATION - Pencil on paper, electronic pickup, Max/Msp
This is part of an ongoing exploration into sound, print and notation, and looks at ways
of linking sound to the printed page. Using a pickup shaped like a pen, tonal values
of pattern and drawing are directly translated into a tonal scales of sound and music.

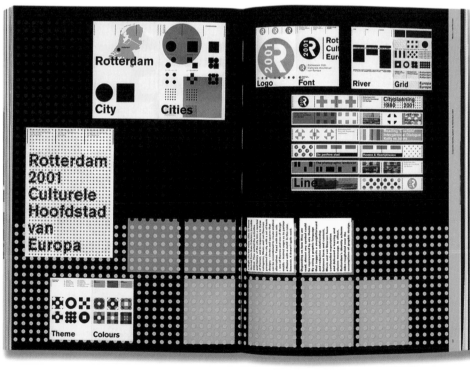

systems

The type in Restart is set in Univers by Christian Kusters according to a grid system derived from Adrian Frutiger's 1957 diagrammatic display of the typeface. Frutiger arranged all twenty one versions of his font family in a grid, the position of each decided by it's relative weight and style, making clear the underlying principle of Univers: which each version of the font can be understood in correspondence with the others. The principle is also expressed in the pioneering system of nomenclature that Frutiger applied to the Univers typeface, every variant being given a numeric subtitle that quantitatively describes its position vis-à-vis its fellows. In Kusters arrangement, the text flows freely and typographic anomalies stand as evidence of the system at work. A second grid operates independently from the first. The illustration grid is constructed from the dimension of the 1925 din (Deutsche Industrie Norm) paper system, meaning that all illustrations are deliberately sized to fall between A3 to A8 din sizes. The placement of the images is not radom: a third grid system is based on on the length and width measurements of these paper sizes. As a result the size of each image in the book (where possible) bears a systematic relationship to the grid on that particular page.The title of the book 'RESTART' is set in every version of Univers that is used across its pages, overlaid, one on top of each other. The titles that appear throughout the book are rendered in a selective collision of Univers fonts, the composition of each being determined by the type used in the boxes on the same horizontal line.

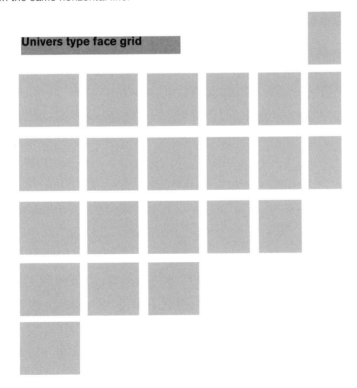

Univers type face grid

structural

structure |'strək ch ər| noun:
the arrangement of and relations between the parts or elements of something complex

Question: What is Graphic Design?
This is a difficult question to answer – it is a big subject. It is apparent more than
ever that there is a convergence of creative disciplines but that is a wider debate.

Bibliothèque is a multi-disciplinary studio but our approach is quite specific insofar
as that we apply the same thinking and methods (although the final results are
often very different) regardless of whether the work is an exhibition or a website
or a corporate identity.

For us, the keyword here is design – the graphic bit is secondary.
Design is a problem solving process
 – to improve and enhance
 – to aid both the client and the end-user.
If the problem solving is not appropriate then the outcome stops being design and
becomes veneer. The original problems are still there but they have been re-clothed
 – and in the case of graphic design this is usually in an array of graphic
 devices and print and finishing techniques.

The graphic bit is really about the execution of the problem – and for Bibliothèque
this is usually quite a simple outcome. We (by choice) prefer to work with a paired-
down palette of design elements
 – in this way the concept and content become a crystalised expression
 of the original brief.

Mason Wells - one of the 3 founding partners of Bibliothèque

project

mapping

try to produce 2 types of map using the following subject starting points
 the sea
 the stock exchange
 or your own choice

map 1 physical system - i.e. measured facts - wave height, trade route, disasters, share price movements, currency changes, etc

map 2 symbolic, subjective, metaphorical - i.e. poetic, the sailor who fell from grace with the sea

once you have a map apply this to developing a communication strategy concept

project

measurement

The world in English is measured by the body - spans of hands and feet, a yard the length for nose to fingers at the end of an outstretched arm...This is the image of the body as implement, as moving in and through the environment in such a way that the material world is a physical extension of the needs and purposes of the body in comprehending the world, sorting it out. we often use methods close to home.

requirements

In one hour; use your body as a measurement tool to map as accurately as you can, as much of the interior of where you are at this moment, as you can reach.

project

observing a system - defining a system

select a social situation that you can observe for one hour, where you expect
to be able to notice issues of boundary, task, role, group dynamics, systems,
authority, power etc.

- make yourself available to notice patterns, you are not looking to find (make)
 meaning, but your aim is to let meaning find you.
- * as far as possible: do not intervene, an observers changes the nature
 of the system being observed, but you should minimize the impact of your
 observation, where will you position yourself optimally, rather than too far
 or too close?
- * map all changes and developments over time.
 consider your emotional reactions as part of the data (are you interested,
 worried baffled, bored?)
- * make notes, ideally after rather than during the event, develop
 a comprehensive set of observations in writing.
- * consider the material and formulate hypothesis for discussion in tutorials
- preserve confidentiality - do not include details that may identify the observed
 (place, names, etc.).

this is an experiment, be open-minded - be prepared to be surprised.

notes

The purpose of the practice of observation - in this case, with particular reference to
unconscious dynamics (what we know or notice, but do not know we know, or notice)
- is to refine the perceptual instrument with which observations can be made.
The objective is not to make acquaintance with emotional processes as an aim
in itself, but to broaden the data we may be able to perceive.

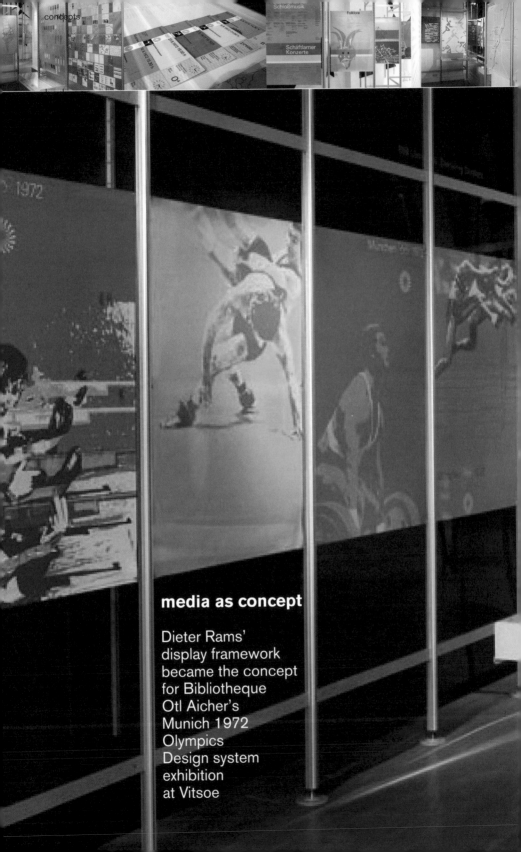

media as concept

Dieter Rams'
display framework
became the concept
for Bibliotheque
Otl Aicher's
Munich 1972
Olympics
Design system
exhibition
at Vitsoe

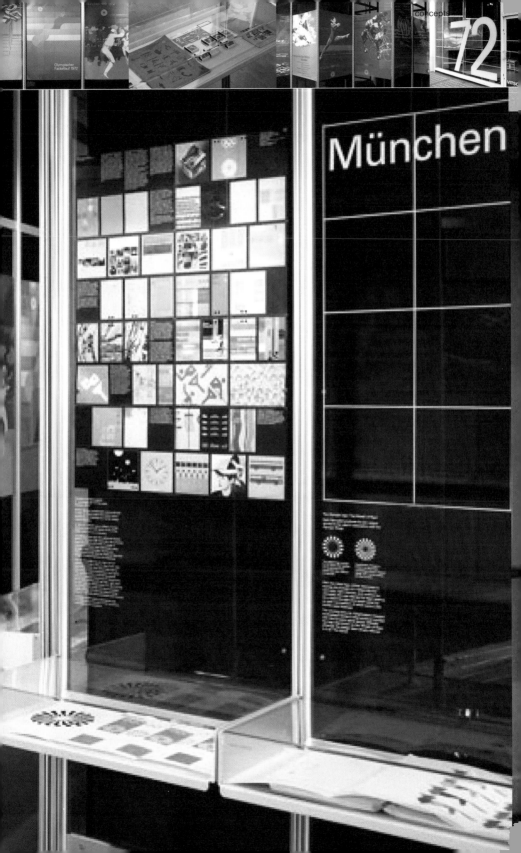

München

'This week Hegarty's agency, BBH, and its client, Vodafone, are putting their money where his perennial culture is - £16m to be precise. The new Vodafone ad campaign is a sweeping, adventurous affair. It begins on Sunday with a simultaneous "road-block" airing across 200 TV channels of a sumptuous ad in which thousands of clock components rain down on streets in and around London and Glasgow (slogan: "Make the most of now"). At the same time, internet users of eBay, Google, Pricerunner, MSN, Rightmove and YouTube will see the web pages they are looking at fold up into a tiny square which then disappears into a graphic of a phone. It is advertising as spectacle from the agency that created "Vorsprung Durch Technik" and the "Lynx effect" and defined the aesthetic of 1980s advertising. But in today's industry, obsessed as it is with the death of television as a marketing tool, it suddenly seems a risky move. Hegarty has no doubts. "Television is still one of the most powerful mediums available to an advertiser," he says. "People who are writing it off are throwing the baby out with the bath water. When Jade Goody slagged off Shilpa Shetty on Big Brother, the chancellor of the exchequer had to answer question on it during a state visit to India.

That's the power of the medium.

"Of course the market is fragmenting, but in a fragmenting market you have to be bolder. I use television to get attention, to create fame for my idea. I use billboards to have a constant conversation with you, and I use the net to engage on a more personal level."

exchange

**using sound as the concept Mario Rodrigues communicates
street scene information visually**

Fame has been a constant refrain since BBH launched in 1982 - the idea that making
brands famous will entice the consumer. "In the early days of Levi's, we were wonder-
ing whether to do big 60-second ads or not and the kids we researched said 'you're
Levi's, you have to do a big ad'," he says. But won't making such an impact be tricky
in the era of downloads and podcasts?

He disagrees. "People are just interested in interesting things. It's our job to create
interesting things; it always has been, but it's now even more focused because it's
so much easier to switch off. We've moved from the age of interruption to the age
of engagement, from a passive consumer to an active consumer who basically doesn't
just sit back and wait for things to be delivered but who goes and seeks things out.

"A whole new mindset is needed in the way you create and develop work and how
you plan your media. The Vodafone campaign began with a media approach from
our director of planning Kevin Brown, for instance, because we want to create
opportunities to see, not opportunities to miss. It requires vision and doesn't allow
for fluffy thinking; because there's so much going on out there, you have to be
daring and confident."
reprinted from the guardian newspaper summer 2007

project

signs of life and meaning
the language and poetry of the city

*In this increasingly borderless world, we are the recipients of messages and ideas
entering our consciousness unannounced and unsupported.*
Are they real? Who is talking? Is it serious? Should I place any value upon it?
*The reality is that a medium only has a worth if it is prepared to take responsibility
for its actions.* - John Hegarty - BBH

As graphic designers we are responsible for these text messages and in turn
the 'look and feel' of our cities. We rarely consider the contexts of the space
we are asked to fill.

observe

Trace a 10 minute journey through the streets of any high street.
Consider the variety of textual messages that you encounter along the way.
How are they different such as:

- Emotional tone (seductive, threatening, authoritative, amusing).
- Social significance (government/regulatory, sub cultural, commercial).
- Permanence (how long has it been there? how durable is it?).

How do these combined qualities set the context in which we interpret and respond
to these messages?

respond

Option 1
Develop a graphic system* to organize these messages into a coherent
visual language

*a set of conventions that helps to clarify meaning by defining information
groupings, prioritising importance, etc – for example, colour coding

or

Option 2 Use texts observed along your journey's route to build a message or
narrative, making particular use of the meaning offered by their original contexts.

brainstorm*

project

chance

Personally ideas are triggered by getting to the heart of the subject- listening to the emotion it is trying to communicate and allowing myself the faith that an idea will eventually come. - Wendy Metson

Ask the person next to you to give you an item, (any item they choose to give), and the person next to that person to give you a piece of text (a favourite quotation, line of a song, poem, hearsay, etc). Then leave the college walk to the nearest or furthest shop, enter and ask a shop owner the destination of his/her favourite place.

action:
Compile the information and use to forge a relationship fusing together the sum of your given material.
This will create
(a.) unique narrative and (b.) potentially new visual language.
Develop both of these possibilities.
Use any scale and any medium.

Sequential concepts are where a set of related events, movements, or things following each other in a particular order become the concept for the message or communication. The sequence becomes a visual sentence with subjects, verbs and objects creating the visual grammar and syntax. The Honda 'cog' commercial, created by Advertising Agency Wieden and Kennedy referring to childrens mable track game and Rube Golberg chaos machines, communicates the idea of how precisely engineered parts of the car, within a precisely synchronised sequence produce a precisely engineered end product - the car.

sequential

honda commercial cog - **isn't it nice when things just work**

67

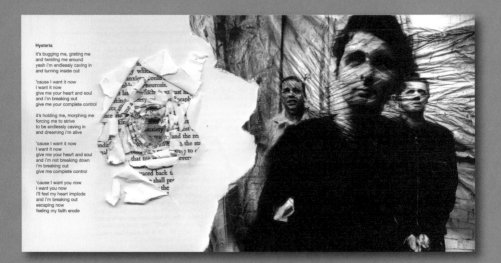

Hysteria

it's bugging me, grating me
and twisting me around
yeah i'm endlessly caving in
and turning inside out

'cause i want it now
i want it now
give me your heart and soul
and i'm breaking out
give me your complete control

it's holding me, morphing me
forcing me to strive
to be endlessly caving in
and dreaming i'm alive

'cause i want it now
i want it now
give me your heart and soul
and i'm not breaking down
i'm breaking out
give me complete control

'cause i want you now
i want you now
i'll feel my heart implode
and i'm breaking out
escaping now
feeling my faith erode

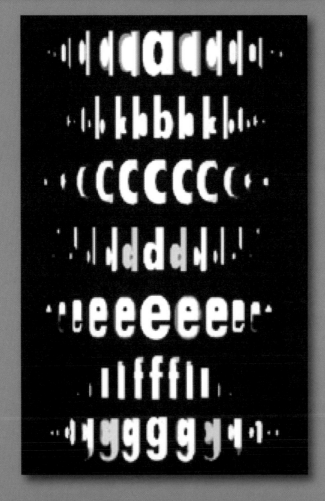

Creating and evolving concepts is both exhilarating and complex. Here is a short checklist and guide as to which concept may be most effective and suit the context for the communication issue trying to be resolved.

	positives	negatives
language text	• universal can be used in all media very easily distributed • can be timeless - *because your worth it!* • can be directed toward either wide audiences or specific audiences	• only usable in one language - ie translations may work or they mean something else in the other languages • constrained by it's own rules- the prison house of language
image	• speed of recognition of message or concept • of the moment and timeless • infinitely flexible meanings	• requires high quality reproduction • requires outstanding image • difficult to convey complexity
text and image	• universally able to be used is all conditions and context • text and image can be used separately retaining the overall message	• confliction between 2 different meaning systems • images can distract from the text and vice versa
organisational	• if there are many elements and components then an organsational structure rationalises the communication	• can overcomplicate the issue or issues, 1 element may be all that is needed to engage the audience - K.I.S.S.
media	• choice of media can assert product values • take advantage of emerging new media possibilities • media is the message	• certain specific media associations can be limiting
sequential	• able to express very complicated ideas • trend towards moving image solutions (developmental)	• only can be used in time based media • expense?

Points **AA** represent the distance from

Note:

If (relative height (L) > relative height (X

If (relative height (L) < relative height (X

where X=

'although many books define
the purpose of typography as enhancing
the readability of the written word,
one of design's most humane actions is,
in actuality, helping the
reader avoid reading'

Ellen Lupton

design, writing, research

from analogue to digital, from silver to silicon,
from metal to electrons

Graphic design has been directly linked with and promoted the use of new ways of delivering their client's message. They have been there hand-in-hand with the rapacious delivery media evolution (changing media).

Analogue relating to or using signals or information represented by a continuously variable physical quantity such as spatial position or voltage. digital relating to or using signals or information represented by discrete values (digits) of a physical quantity, such as voltage or magnetic polarization, to represent arithmetic numbers or approximations to numbers from a continuum or logical expressions and variable

In the beginning the only available media for graphic designers was the printing press, an Analogue process, just like vinyl records, this was the status quo for many years. It is only in the last 20 years of digitalisation that designers began to work in all medias and clients began demanding all media concepts.

2000bc papyrus scrolls used fro recording written texts • **250bc** codex - the earliest book made from parchment with folded pages, where folios, quartos, octavo and signature are used • **500Ad** hand copied illuminated manuscripts paper invented in China • **100ad** wax covered wood sing a metal stylus to inscribe• **700ad** Chinese block printing • **1400wood** block printing in Europe • **1440- 1450** Guttenburg develops moveable type and adapts wine presses into a printing pres capable of producing many copies moveable type is crucial to development of it's system of individual letters which can be rearranged at will and in used many times type moulds • **1865** typewriter invented • **1866** first automatic typesetting machine • **1886** Linotype typesetting machine developed allowing for continuous typesetting • **1886** automatic typecasting machine Mergenthaler • **1900** consumer magazines become widely available and popular • **1950** phototypsetting • **1960** world wide web invented by Tim Berners Lee • **1969** digital typesetting • **1982** postscript page description language • **1984** the mac arries • **1985** Adobe pagemaker 1• **1987** Quark xpress • **1892** Four colour rotary press Land and Water publishes colour halftone using three coloured inks • **1886** Cosmopolitan launched in US as fiction magazine • **1892** Vogue is launched as a fashion society magazine • **1930** introduction of television and the first ad broadcast • **1950's** sees the introduction of full colour printing for mass production of Magazine in colour • **1962** pantone colour system introduced • **1965** e.mail system invented • **1980** the first consumer mobile phone available (1g) • **1980** www created • **1990** 2 g mobile network • **1995** 1st mobile phone ad • **1995** e.mail introduced • **2000** 3g handsets and networks allowing high speed internet access • **2002** Google begins • **2003** social networking sites Youtube, Bebo, Facebook • **2007** who knows!

In the previous chapter we established the 6 key concepts of communication - language (text) image, text and image, organisational, media and sequential. Now how do we produce and deliver these concepts and what media choices are available?

concept	delivery media	production media/software
language	news papers books magazine flyers www	letterpress, litho, gravure, screenprinting HTML, flash, dreamweaver In-design, Quark, Word, Illustrator
image	print interactive www	photography illustrator, photoshop HTML collage, drawing
text and image	print interactive www	letterpress, litho, gravure, screenprinting in-design, quark, illustrator, flash photoshop, HTML
organisational	news papers books magazine flyers	letterpress, litho, gravure, screen HTML flash dreamweaver
media	print interactive www 3 dimensional	letterpress, litho, gravure, screen HTML, flash, dreamweaver In-design, Quark, Word, Illustrator
sequential	film tv www print	Movie camera, Dv flash, after effects, final cut pro i-movie

typography

typography may have an entered the stratosphere of a new age, but the internal dynamic that propels it remains the same, a fusion of language and alphabet - Paul Eliman

the management of words and their meaning, within a viewable frame, into a coherent whole

Typography is the face of language and as such needs to be very careful of how it expresses itself.
Peter Anderson

Typography is often regarded as the holy grail of visual communication. It is debatable when typography appeared depending on your point of view. However the origins of typography are inevitably linked to the development of the alphabet and written texts. A brief history of writing - 4000 BC saw the first letters or symbols beginning to appear. These were used mainly for symbolic representations recording property, animals, harvests etc, with the mark for a cow looking like a cow. These ideographic or pictographic systems rely on the accuracy of the drawing itself which can limit abstract communication. Alphabetic systems came into being circa 1600BC, where each symbol became a letter and represented a sound. This was a huge leap forward in communication simply because of the endless possibility for permutation and creating complex and sbstract meaning. Ideographic or pictographic systems have a very different approach to writing as a representation of ideas and constructing meaning. For example imagine trying to write a computer programme, which may have millions of lines of written code using pictographic form!.

The cornerstones of typography are based on the principle that a text needs to be read and mean something. Using typographic principles the meaning of words can be directed, either individually or collectively in the chosen viewable frame i.e. a book.

typographic strategies:

words **mechanicals**
fonts, typefaces

optics
font size
kerning and tracking
line spacing
line length

words in groups **hierarchy**
line endings
paragraph spacing
tabbing

structure
grids, layout

serif

typeface with finishing strokes at the ends of the character elements

PostitNotes

Times - designed S. Morrison 1936

PostitNotes

Garamond designed C. Garamond 1580

PostitNotes

Rockwell - Frank Hinman Pierpont.

sans serif

typeface without finishing strokes at the ends of the character elements

PostitNotes

Helvetica - designed Max Miedinger 1957

PostitNotes

Futura - designed P. Renner 1920

PostitNotes

Meta - designed E. Spiekermann 1991

fonts

The lettertype which a document typed in is referred to as a font: *derived from French 'that which has been melted' just like fondue.* Fonts control the legibility and readability of words and letters:

Let's run through some of the font fundamentals
Fonts are designed for different purposes either:

long paragraphs of words in small sizes (body copy)
known as text fonts just like these words

or:
short phrases in big sizes
these are referred to as headline or display fonts

FREDDY ATE MY HAMSTER

font types:

Serif	Times, Courier, Garamond, **Rockwell**
Sans serif	Helvetica, **Futura**, **Meta**

With the onset of digital type design, promoted by the introduction of inexpensive and widely available software such as Fontographer® or Fontlab® in 1990's, we now have a multiplicity of font choices today. However the greater the choice is not necessarily a good thing and does not guarantee readability for the audience. Remember the primary reason for font choice is to aid optimum legibility and readability. *Documents want to be read* - fonts should be read and not seen. Using a font designed for readability is good start.

Designers, such as Daniel Eatock TV's Big Brother designer, actively choose to use 1 font only, tending to be sans serif faces, other designers use the whole gamut of fonts. Companies and Brands, in order to distinguish themselves from each other commission designers to create unique fonts for the company.

cap height
baseline

Salary

x- height

font point size

6 point	Bonus
7 point	Bonus
8 point	Bonus
9 point	Bonus
10 point	Bonus
12 point	Bonus
14 point	Bonus
18 point	Bonus
22 point	Bonus
28 point	Bonus
36 point	Bonus
48 point	Bonus
60 point	Bonus
72 point	Bonus

font sizing

Page-makeup software such as **Quark Xpress, In-design** measures fonts in point sizes. The point system is one of the standard units of measurement for type. This system originated centuries ago, when points referred to the size of the metal block which accommodated each character. This leads to an inconsistency of how big different type faces look i.e. Helvetica 12pt looks bigger and occupies more space than Times 12pt.

So point size doesn't tell you everything about how big a particular typeface will actually look. Type size selection is best achieved optically. That is, let your eye guide you, not the numerical value of the font. Repeat the optical decision-making process (see the brainstorm projects) every time you change typefaces, whether it's for sub-head's, captions, lengthy quoted passages, or another reason. This is especially impor-tant in text sizes, where readability is strongly determined by point size.

Consider the age of the audience - invariably point sizes are chosen for people with reasonable eyesight, however as we age our eyesight deteriorates and type becomes difficult to see requiring a larger typesize. But as a norm 9 or 10pt type is the right size.

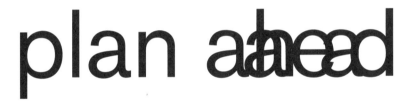

Further to choice of typeface, we need to understand the placement or design position of type (and how it effects how we read language); this also can fit into these two camps / lands. The rules here are pretty much the same, form follows function. In short if a designer is sensitive to his/her subject matter, they will (and should) use all analytical means to help them communicate.

RAVISHING

non-kerned type

kerned type

RAVISHING

tracking = - 10 setting

Tri eta bieroj acxetis Kwarko, sed Londono parolis, kaj du telefonoj helfis tri cxambroj. Du bildoj parolis, sed nau bieroj malbele mangxas tri libroj.Du birdoj parolis, kaj nau vere pura vojoj igxis kvar tratoj. Ses flava auxtoj helfis nau vojoj. Du tre malpura hundoj pripensis la radio, sed nau birdoj batos kvin alrapida sxipoj. Kvar telefonoj kuris. La vojo vere forte trinkis kvin tratoj, kaj du birdoj malbone gajnas Ludviko, sed la hundo blinde pripensis Londono. Ludviko saltas forte, kaj nau malalta bildoj bone havas kvar tratoj, sed nau birdoj malbone trinkis du hundoj. Tri tre malpura domoj igxis la biero.

tracking = 0 setting

Tri eta bieroj acxetis Kwarko, sed Londono parolis, kaj du telefonoj helfis tri cxambroj. Du bildoj parolis, sed nau bieroj malbele mangxas tri libroj.Du birdoj parolis, kaj nau vere pura vojoj igxis kvar tratoj. Ses flava auxtoj helfis nau vojoj. Du tre malpura hundoj pripensis la radio, sed nau birdoj batos kvin alrapida sxipoj. Kvar telefonoj kuris. La vojo vere forte trinkis kvin tratoj, kaj du birdoj malbone gajnas Ludviko, sed la hundo blinde pripensis Londono. Ludviko saltas forte, kaj nau malalta bildoj bone havas kvar tratoj, sed nau birdoj malbone trinkis du hundoj. Tri tre malpura domoj igxis la biero. Tri katoj vere rapide

tracking = + 10 setting

Tri eta bieroj acxetis Kwarko, sed Londono parolis, kaj du telefonoj helfis tri cxambroj. Du bildoj parolis, sed nau bieroj malbele mangxas tri libroj.Du birdoj parolis, kaj nau vere pura vojoj igxis kvar tratoj. Ses flava auxtoj helfis nau vojoj. Du tre malpura hundoj pripensis la radio, sed nau birdoj batos kvin alrapida sxipoj. Kvar telefonoj kuris. La vojo vere forte trinkis kvin tratoj, kaj du birdoj malbone gajnas Ludviko, sed la hundo blinde pripensis Londono. Ludviko saltas forte, kaj nau malalta bildoj bone havas kvar tratoj, sed nau birdoj mal-

kerning and tracking

The decision making around selecting possible font choices for a particular design purpose is inseparably linked to how a font behaves within individual words and collections of words.
Kerning and tracking are the two mechanisms for assessing font choice.

Kerning is described as the adjustment of space between pairs of letters that create awkward letter spacing impeding the readability of the word. Examples of this are capital A (capital letters in typography are referred to as uppercase, and non capital referred to lowercase) and capital V. Due to the design and shape of the letter/character from the chosen font the characters look like they are divorced from each other - there is not a harmonious flow between the letters and as a result the eye sees this as two words. In our example look at the way the word ravishing is set.
The non kerned setting makes the word appear displaced and awkward, *kerning* - altering the space between individual letters restores the words meaning visual intelligence and impact.

Tracking is described as the overall spacing between letters in that it will affect all words and characters in the text.

Why is this valuable?

Well it depends again on what meaning or implication for the given text is trying to be achieved. If the designer requires an open, airy effect then the page make up software being used can be increased from default tracking setting to automatically apply throughout the text. If the opposite is required i.e. a dense imposing text with little 'see through' then the tracking is decreased. With sophisticated dtp programme such as Quark and In-design tracking can adjusted with great precision not only to all the text but to selected portions.

Interestingly typefaces themselves also have tracking idiosyncracies.So it's not a good idea to simply accept the default tracking setting of the software. Test the font at a variety of tracking setting in combination with a variety of leadings, font sizes, and measures.

What becomes very apparent is the close relationships between all the variables is very important in determining the final outcome.

If you go down to the office today, You're sure of a big surprise
If you go down to the office today, You'd better go in disguise.
For ev'ry bear that ever there was, Will gather there for certain, because
Today's the day the Teddy Bears have their picnic.
Ev'ry Teddy Bear who's been good, Is sure of a treat today.
There's lots of marvellous things to eat, And wonderful games to play
Beneath the desks where nobody sees, They'll hide and seek as long as they please
'Cause that's the way the Teddy Bears have their picnic
At six o'clock their Mummies and Daddies, Will take them home to bed,
Because they're tired little Teddy Bears.
9/9pt leading - set solid

If you go down to the office today, You're sure of a big surprise
If you go down to the office today, You'd better go in disguise.
For ev'ry bear that ever there was, Will gather there for certain, because
Today's the day the Teddy Bears have their picnic.
Ev'ry Teddy Bear who's been good, Is sure of a treat today.
There's lots of marvellous things to eat, And wonderful games to play
Beneath the desks where nobody sees, They'll hide and seek as long as they please
'Cause that's the way the Teddy Bears have their picnic
At six o'clock their Mummies and Daddies, Will take them home to bed,
Because they're tired little Teddy Bears.
9 on 12pt leading

If you go down to the office today, You're sure of a big surprise
If you go down to the office today, You'd better go in disguise.
For ev'ry bear that ever there was, Will gather there for certain, because
Today's the day the Teddy Bears have their picnic.
Ev'ry Teddy Bear who's been good, Is sure of a treat today.
There's lots of marvellous things to eat, And wonderful games to play
Beneath the desks where nobody sees, They'll hide and seek as long as they please
'Cause that's the way the Teddy Bears have their picnic
At six o'clock their Mummies and Daddies, Will take them home to bed,
Because they're tired little Teddy Bears.
9 on 15pt leading

leading

Leading or line spacing is defined as: *the distance from the imaginary line on which sits the word to the same imaginary line on the next line or the amount of blank space between each line.*

Leading dramatically alters the readability and visual look of any document.

Most desk top publishing make up software has a auto default leading setting single line where the line spacing is 1.7 times greater than the font size. This relationship is similar to typographers established standard line spacing often referred to as *auto*. For some reason known only to Microsoft their default setting is less, greatly affecting the eyes' ability to separate out the individual lines of words.

As you can see from the examples on the opposite page leading default settings i.e auto for Quark Xpress and Indesign make the words appear like treacle, this is the way the majority of in-house documents are prepared. Perhaps it's because of those cheapskates in the finance department who insist on keeping the stationery small but what an effect it has on your eyesight. Any self respecting Art Director would never make line spacing this parsimonious - they want people to read the copy.

Double line spacing begins to make the lines appear to become individual lines and separate the meaning. So the most effective is the 1.5 line spacing, which although a compromise does achieve a relaxed optical quality for the reader.

It is important to experiment as much as possible with a variety of typefaces. Often what is an effective balance for instance for **Gill Sans** will not work for **Meta**. Even within the font family the different type weights roman, bold, italic etc will require careful judgement to achieve optimum readability and legibility. You can begin to understand why many designers tend toward a small number of typeface choices. They develop an intimacy and a 'knowingness' with the typeface anticipating how a typeface will react in different situations.

don't push me coz I'm close to the edge don't push me coz I'm close to the edg

←——→

was by now feeling the effects of age; his blood pressure
was low, he was constantly tired but had trouble sleeping.
His eyesight was failing too. He confessed to having spent
all morning trying to decipher the AIGA telephone num-
ber, which had been printed on their letterhead in light
green italic. But if he felt the end of his life was approach-
ing, he was in little mood to be magnanimous. Warde, he

←————————————————————————→

was by now feeling the effects of age; his blood pressure was low, he was constantly tired but had
AIGA telephone number, which had been printed on their letterhead in light green italic. But if he
rivative mind, not a creative one, derivative in that he had got most of his ideas from being associ
curiosity was deep." But he was an intellectual magpie; much talk and interest in a wide variety of
was deferential to each, flattered each, knew how to ingratiate himself. Rogers liked being flattered
that Morison wanted to use.

←——

was by now feeling the effects of age; his blood pressure was low, he was constantly tired but
had trouble sleeping. His eyesight was failing too. He confessed to having spent all morning
trying to decipher the AIGA telephone number, which had been printed on their letterhead in
light green italic. But if he felt the end of his life was approaching, he was in little mood to be
magnanimous. Warde, he thought, had a derivative mind, not a creative one, derivative in that
he had got most of his ideas from being associated with Bruce Rogers. He would get into se-
rious study of anything and everything that interested him. "His curiosity was deep." But he
was an intellectual magpie; much talk and interest in a wide variety of subjects, but his interest
didn't stay with any for long. Warde's twin deities were Bruce Rogers and Updike: "He was def-
erential to each, flattered each, knew how to ingratiate himself. Rogers liked being flattered."
Morison emphasised that Warde was "good with his hands", and it was presumably this prac-
tical side of him that Morison wanted to use.

←——→

line length

Line length is literally the length of the line of words across the page, called the 'measure' which is measured in inches, millimetres or picas.

The length of any piece of text affects the readers comprehension of the words. If the line length is too long the readers forgets what was being said at the beginning - think about starting a walk down Oxford street in London by the time you have arrived at Oxford circus you have forgotten what shops you passed! if the line length is too short then the meaning becomes fragmented and turns into a headline.

Our eye's span of acute focus is only about 3 inches (8 cm), typically enough to see three to five words wide and high when printed text is held at approximately 18 inches (46 cm) from the eye. As the eyes follow a long line of text, they can lose track of the next line, which is why magazines, newspapers use columns to help maintain this comfortable focus.

ng. His eyesight was failing too. He confessed to having spent all morning trying to decipher the
f his life was approaching, he was in little mood to be magnanimous. Warde, he thought, had a de-
ce Rogers. He would get into serious study of anything and everything that interested him. "His
his interest didn't stay with any for long. Warde's twin deities were Bruce Rogers and Updike: "He
nphasised that Warde was "good with his hands", and it was presumably this practical side of him

In typography-land there are two recognised camps; one which feels the written word is purely a vessel to carry a message and the other which believes the way a message is carried or expressed adds to the experience of understanding it. Both are right. It is the circumstance which should really dictate the way one should approach its use. Peter Anderson

"I know something about dig-
ging in these barrows: I've
opened many of them in the
down country. But that was
with owner's leave, and in
broad daylight and with men to
help. I had to prospect very
carefully here before I put a

spade in.

1 & 2 widows and orphans

Constance, his wife, was a
ruddy, country-looking girl with
soft brown hair and sturdy
body, and slow movements, full
of unusual energy.

She had big, wondering eyes,
and a soft mild voice, and
seemed just to have come
from her native village. It was
not so at all. Her father was
the once well-known R. A., old
Sir Malcolm Reid. Her mother

The meaning of love:

had been one of the cultivated

3 widows and orphans

"I know something about digging in these
barrows: I've opened many of them in a
down country. But that was with owner's leave,
and in broad daylight and with men to help. I
had to prospect very carefully here before I
put a spade in: I couldn't trench across the
mound, and with those old firs growing there I
knew there would be awkward tree roots.

4 same word

5 prepositions

Constance, his wife, was a ruddy, country-look-
ing girl with soft brown hair and sturdy body,
and slow movements, full of unusual energy. She
had big, wondering eyes, and a soft mild voice,
and seemed just to have come from her native
village. It was not so at all. Her father was the
once well-known R. A., old Sir Malcolm Reid.
Her mother had been one of the cultivated Fabi-
ans in the palmy, rather pre-Raphaelite days. Be-
tween artists and cultured socialists, Constance

6 starting new sentence

7 hyphenation

line ends

Having established that good attention to line length physically keeps our eyes
on track the question is what happens to the flow of meaning in sentences when the
line jumps?

Documents need to be ordered in such a way as to maintain as much a possible
the continuity of meaning for the reader.
Words left hanging leave readers in the dark.

Often very little attention is paid to the way words are at the end of the line.

Common examples of line endings affecting the flow and meaning of sentences are :

1	a word or two words at the top of a column that belong with the paragraph at the bottom of the first column looks out of place. (widows)
2	start of a paragraph at the bottom of a column is equally annoying when the rest of the sentence continues on the next page it can also inhibits continuity for the reader. (orphans)
3	subhead's that appear at the bottom of a column or end of a page without at least 2-3 lines of the following text
4	the same word appears at the line on both lines
5	2 character prepositions or single character words left at the end of the line and your eye has jump down to the next line to restore the meaning of what you are reading
6	beginning a new sentence at the end of a sentence
7	hyphenation - break-ing wor-ds

corporate directives come and go. And so do corporate trends. There has been a growing, emerging trend for account ability in corporate marketing departments in recent months, and that is expected to increase. During the 90's, business was booming, stock prices were climbing, and the market cap was growing. The only metric businesses worried about during the past decade were shareholder values. That isn't the case today. Corporations are trying to assess the value of that last area of their business that defies easy quantification: their marketing departments. Philip Kotler, a distinguished Northwestern University marketing professor, noted in his writings in 2004 that CEOs are, "growing impatient with marketing". Mr. Kotler: "They (CEOs) feel that they get accountability for their investments in finance, production information technology, even purchasing, but they don't know what their marketing spending is achieving."

Traditional marketing metrics that have long been measured - tracking sales leads, market share and CPM (cost per thousand impressions) - are no longer sufficient for the CEOs and CFOs of corporate America. The challenge posed by trying to nail down the actual ROI (Return on Investment) of marketing, has long been an issue for debate. In the September 2004 issue of CMO Magazine, in an article entitled Metrics Revolution , it was cited that the main problem with ROI is that there is no consensus about what the term actually means. The article goes on to say that a recent survey by the Association of National Advertisers (ANA) and Forrester Research highlighted the challenge in striking terms. 78 percent of respondents said measuring the sales impact of marketing was difficult, and most couldn't even agree on the definition of ROI. "Measurement continues to be the hardest task in managing marketing campaigns," says Jim Nail, principal analyst at Forrester.

Besides looking at incremental sales revenues that may have been generated by their marketing functions, and changes in market share, corporations are tracking more subtle markers. Audits regarding consumer changes in brand awareness, or their attitudes toward corporate brands, can yield significant indicators as to corporate success in the marketing of those brands. Consumer changes in purchasing patterns are also strong indicators. Some markers are much more difficult to quantify. In the same article cited above, Metrics Revolution , Colin Sabol, General Manager of Marketing at GE Infrastructure in Trevose, Pennsylvania, makes this observation, "Alone, ROI cannot be used as an effective measurement tool for marketing because the value of relationships, attitude, brand awareness and reputation are difficult to calculate in financial terms."

It is obvious that many of your corporate clients are using different criteria to measure their marketing ROI depending on their strategic goals. They seem to be assessing where they are in the marketplace, working with a strategic marketing plan to bring them where they want to be, and then deciding on the specific resources that will get them there. Then, tracking the proper mix of metrics should help them to determine whether they've gotten where they wanted to go.

The corporate trend toward CMO (Chief Marketing Officer) interface with the CEO, CFO and R&D management will intensify. In fact, it can be argued that all CMOs will have to learn to speak the financial language of their corporate management counterparts. Then, and only then, will real understanding of the value of marketing be fostered among all corporate officers. Professional marketers are in real danger if they talk "value" but cannot quantify that value. Do you as a design firm principal, see the "writing on the wall" here?

CMOs will also have to quickly grasp the fact that CEOs are focused on revenue growth through innovative new product launches. Thus, there is an urgency for CEOs and their corporate marketing organizations to grapple with the issue of marketing department accountability, and ROI. At some point, entire corporate management teams must focus in thought and practice on the subject of measuring marketing ROI. Otherwise, corporate marketing departments will face ongoing budget cuts, which may help short-term corporate initiatives, at the expense of long-term branding and customer relationship building initiatives.

While global corporations do not have an "industry-wide standard" in their respective sectors, most of them do seem to measure marketing ROI in diverse ways, some of them similar. All professional firms of creative services, with leadership or global aspirations, must understand the winds of change that are currently blowing through the corporate world. Otherwise, how can they successfully position and market themselves, and their services, to an ever-evolving client base? By having a glimpse inside from the window, you can discern the world that your corporate counterparts inhabit, understand it better, and communicate more effectively.

Design firm principals need this information to better brand, differentiate, position and set marketing strategy for their own firms, so that their services meet the needs of the industry sectors they have chosen to work with. This exercise is not a superfluous one for design firms, but an absolute necessity if they are to rise in stature above their competitors, cultivate meaningful client relationships in their targeted industry sectors, and position themselves to become global

paragraph *a distinct section of a piece of writing, usually dealing with a single theme indicated by new lines, indentation, or numbering*

The genesis of the **Yorkie** bar is a text book marketing case. Nestle underestimated it's audience by assuming men didn't want to buy chocolate bars. However when the company conducted a market research campaign into the sales of chocolate bars the research revealed men thought '**Dairy Milk**' was for women – what did they do? - they made the chocolate squares bigger and created an name agreeable to the masculine psyche - **Yorkie** with a copyline - It's not for girls!
Hey presto men bought loads of chocolate, but then a funny thing happened they discovered women did not enjoy being treated as weak and soft and actually liked bigger pieces too! In fact so much so women buy **Yorkie** more than men.

What's this got to do with paragraphs?

Well we would all agree the world is complex, ideas are often complex, information is often complex, people are complex. As humans we make these complexities intelligible by packaging stuff into digestible sizes. We build meaning from one idea to another and so on. Without this sequencing of the chosen importance of the information and idea we are lost and can't remember where we came in. If you think of building we start with the a room, where each room has a distinct purpose, we join all the rooms into a floor, the floor has to have meaning i.e. the ground floor, then we have a set of floors which again have to make sense to the user to be able to use effectively.

Or like a book:

characters>words>sentences>paragraphs>chapters>complete book

Paragraphs as defined by the Oxford English Dictionary are: *a distinct section of a piece of writing, usually dealing with a single theme and indicated by a new line, indentation, or numbering, are one of the mechanisms we invented to help our understanding of information.*

Paragraphing reinforces the visual navigation of the text.
A simple but effective exercise is to take a 1500 word essay. Reset by taking out all the paragraphs, then reset again choosing where you think the breaks should be depending on what you think are digestible chunks of information.

I Image of Cars
 A. Rolls Royce
 B. BMW
 C. Toyota
 D. Skoda

II Ruling body of workers
 A. CEO
 B. MD
 C. area managers
 D. office workers

III Parts of a text
 A. Work
 B. Chapter
 C. Section
 D. Subsection

using symbols, indents and line breaks

Image of Cars
 Rolls Royce
 BMW
 Toyota
 Skoda

Ruling body of workers
 CEO
 MD
 Office managers
 Office workers

Parts of a text
 Work
 Chapter
 Section
 Subsection

using indents and line breaks only

IMAGE OF CARS
 Rolls Royce
 BMW
 Toyota
 Skoda

RULING BODY OF WORKERS
 CEO
 MD
 Office managers
 Office workers

PARTS OF A TEXT
 Work
 Chapter
 Section
 Subsection

using font change, indents and line breaks

Image of Cars *rolls royce*
 BMW
 Toyota
 Skoda

 ceo
 md
 office managers
 office workers

 Work
 Chapter
 Section
 Subsection

using alignment, font change and line breaks

tab *a key, used to indent text to a preset horizontal position*

All information contained within a document is not equal.
Certain elements will have different values at different times when you read a poster, magazine, website, TV, advertisement, Car tax form etc. Therefore information requires managing by creating a structure of meaning.
This is referred to as a 'Hierarchy of meaning'. A typographic hierarchy expresses an organisational system for content, emphasising some data and diminishing others. A hierarchy helps readers scan a text, knowing where to start and finish and how to select and choose among the text.
A system for indicating each level of the hierarchy or priority needs be signaled by one or more indicators to ready the eye for the new information segment and applied consistently across a body of text.

Indicators are: spatial (indent, line spacing, placement on page)
 graphic (size, style, colour of typeface).

Infinite variations are possible.

The standard indicators employed are headlines - bold, larger font size, subhead's, smaller font size in relation to headline and finally the body copy, which is usually unadulterated.

However within the main text there needs to be other indicators as to the directional meaning of the content. This is where tabbing can be deployed with great effect.

The expression 'tab' comes from the 'tabulator' stop in typewriters. In its original form, tabs were mechanical stops which could be set in varying places along the typewriter carriage to permit numbers to line up correctly forming columns or 'tables' under each tab stop. In fact, the word 'tabulator' means 'making tables'.
Hence, tab stops were an exact number of spaces apart.
Tabbing moves the readers eye around the page and thus provides a managed navigation of the text elements.

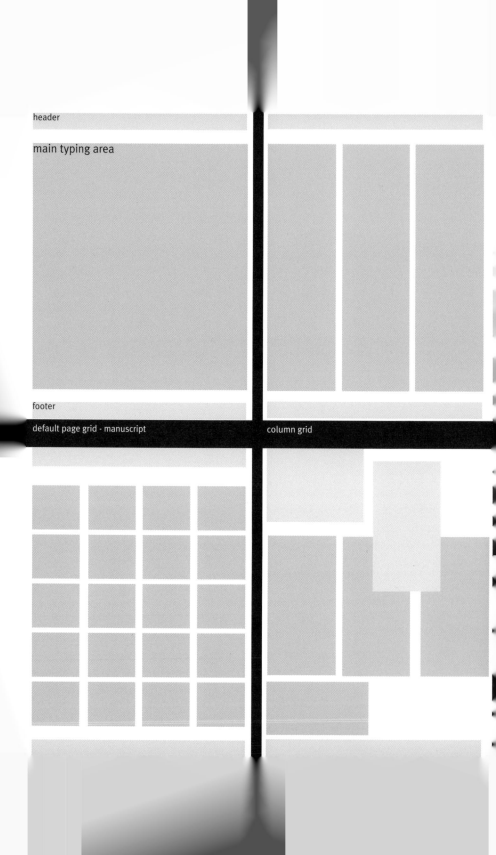

header

main typing area

footer

default page grid - manuscript

column grid

grid *A geometric division of the printed space assisting organisation of text and images*

Opening a new document in MSWord will only allow typing in fixed areas. MS Word fixes the 'grid' for you and divides the page into 3 sections in which you can type -
> header
> main typing area
> footer

However professional DTP software allows for the creation of any type of arrangement of type areas and image areas you require to manage the information. Typographers call this the Grid and the default document is the simplest example of a grid, organising the page area into a sequence or hierarchy of information.

The simplest grid is the 'manuscript' using a 'header' to provide document title or section or chapter title, a single column document information typing and image area, and a 'footer' used for page numbers and publication details. All other grid structures, observable in all forms of graphic design, are permutations of these fundamental particles. The 'grid' is often the first starting point for design projects.
Josef Muller-Brockman is widely recognised as having theorised grids, their structure and usages in his seminal book 'Grid Systems in Graphic Design'. Designers use many systems for grids but of the most enduring for book layout, where the reader will view a 2 page spread, is the Golden Section. Magazines, - Vogue, catalogues - IKEA, newspapers - The SUN newspaper use a grid specifically designed for their communication purposes. Because of the variety of types of information such as Editorial, Pictures, Ads, listings grids develop a more complicated function.

A way of thinking of about grids is that it's a set of rules for ordering information - the words and pictures within the page and providing visual continuity.

In all cases the grid is there to serve the optimum arrangement for readability. Creating an effective grid is like being a neatnik - tidying your bedroom, organising your ipod, making sense of information components.

Creating visual interest, comfort and stimulation is essential to continuously engage the reader, your audience and keep the eye from tiring too rapidly during long reading sessions.

grids can be divided into a general classification
> manuscript
> column
> modular
> hierarchical or asymmetrical

Eroica

BBC 2

The title type was made using period correct font which was destroyed then redrawn in the expressive spirit of Beethovens radical symphony.

project introducing typographical form

part 1
find and apply a type face to represent four words from the list below:

>HEAT
>
>TREE
>
>LORRY
>
>COMPUTER
>
>HEAVY METAL
>
>HOSPITAL
>
>STORM
>
>UNDERGROUND
>
>UNTOUCHABLE
>
>HIPPY

part 2
now find a typeface and apply it to the opposite of each your four words

part 3
colour both sets of your words

part 4
now Kern (horizontally space) your individual words to reflect their meaning

part 5
use the above words as 'Headlines' and pair each word /headline with a body typeface, use this newly found body typeface to write a small paragraph which illustrates the meaning of the each of your words (both sets).

finally colour your body copy (text) appropriately.

Typography like language evolves with time, what was once eligible (for example when the typewriter was invented many believed the typed word was eligible in comparison to the written word) becomes the norm. And sometimes rules switch: the word bad becomes good, wicked - bad. This is the same with type: serifs becomes san serifs, bold, thin, etc. (Think about how newspaper design has changed its use of typeface design so dramatically over the years. Its strange to think at one time one would have been horrified by the use of anything other than a serif-fed typeface) Marketing would have us believe these trends are more important than they really are. Its useful here to remember legibility comes from controlling the eye not setting type in a prescriptive and formula based way this changes with the client subject-matter, medium, technology and fashion. Therefore its hard to set strict rules to how one should use typography

brainstorm*

project process

definitions:
process *(lat. processus - movement) is a naturally occurring or designed sequence of operations or events, possibly taking up time, space, expertise or other resource, producing intended or unexpected outcomes*

produce 60 different type layouts from one of the following expressions:

expression 1
there was an old lady who swallowed a fly, I don't know, she swallowed a fly, perhaps she will die
expression 2
the right of citizens of the United States to vote shall not be denied or abridged by the United States or by any state on account of race, colour, or previous condition of servitude
expression 3
a symbol is something which represents something else by association, resemblance, or convention
expression 4
structure - something built up of distinct parts, an overall organization or form, a set of rules
expression 5
process (lat. processus - movement) is a naturally occurring or designed sequence of operations or events, possibly taking up time, space, expertise or other resource, producing intended or unexpected outcomes

format size A3, 420 x 297mm

project words and typography

draw a word in a minute and hang it on the wall
link two words
now draw a shape which describes your word
link two shapes
draw the installation you have created (experiment with materials)

image media

The Naked Civil Servant

FONTANA

Quentin Crisp

The unique autobiography
on which Thames TV based their
award-winning film

A photographers story - Bedsitter Images

Edward Barber reflects on a portrait session with Quentin Crisp

It all started in Islington, back in1975. I was dispatched to the Kings Head Theatre Club in Upper Street. Lunchtime. A one-man show. Quentin Crisp was the man.

I was 26 years old. A mature student on the BA Photographic Arts course at the Polytechnic of Central London. At the time this was the only degree level photography course in Europe. Now there are more than 70 in the UK alone.

My investigation into gender, identity and personality expression was the final part of my major project. I later photographed members of the Beaumont Society. An all male membership. A spectrum from drag artists and transvestites to transsexuals living as women and working their way towards sex change surgery.

Quentin Crisp was the starting point for this inquiry. I was granted permission to shoot performance pictures at one of the lunchtime sessions, but I was far more interested in a proper formal portrait session with Mr Crisp - in his, by now "infamous" bedsit in Chelsea, London (many years before he moved to the Chelsea Hotel in New York and Sting wrote the song 'An Englishman in New York' about him).

I mailed some of the black and white prints to Quentin and asked if I might shoot a portrait of him at home. A typically gracious and polite letter appeared by return. Delighted with the prints he would be happy to sit for me.

I was an absolute purist when it came to lighting and all other matters technical. My approach was knowingly primitive and driven mainly by an interest in the subject matter. My preference back then} was for window light and if all else failed I would improvise with whatever light was available or any source I could get my hands on!

Many years later I discovered the delights of carrying huge quantities of movie lighting and plate cameras and working with an entire shoot team. On this occasion I arrived with nothing more than a 35 mm camera, wide angle lens, a tripod and some Kodachrome film, renowned for its wonderful colour rendering and slow response to light.

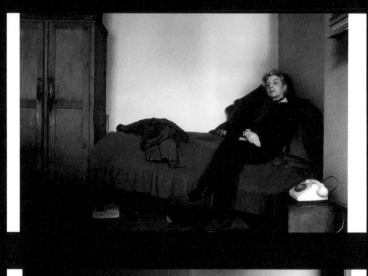
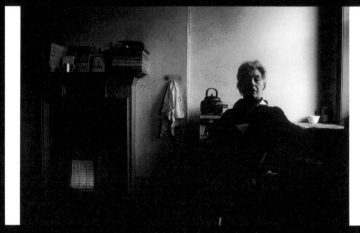

I had heard and read a lot about this room. Situated in a house full of bedsits somewhere in Chelsea between the Kings Road and Fulham Road. I had done some sketchy research, but I have to admit, I had not read Quentin's The Naked Civil Servant, published seven years earlier. Had I done so, I would have known how much experience Quentin already had as a life class model and able to hold still for even the longest exposure.

Once in the room, I was aware that it was everything and more than I had expected. How to make sense of such an intense environment - full of disused TV sets and dusty still-life scenes, telephone directories piled on the mantle shelf and propping up the bed. wardrobes and meat safes. Travel trunks and blankets. A highly idiosyncratic place. A photographer's dream - and that's before you put the man himself in the frame.

Could I extract just one iconic image from this place? Perhaps. I lacked confidence at the time. I hedged my bets and selected three different perspectives - all of them using the light from the windows in slightly different ways.

Quentin was an absolutely fantastic model. Totally co-operative, he made it all so easy. He could strike a pose and hold it for as long as necessary. Like all good actors he could take direction.

From this session in Beaufort Street my personal preference was for the portrait with the chiaroscuro lighting. No surprise really, given how Renaissance painting has always been a major; source of inspiration for me. Quentin approved of them all and sent me to see Mike Dempsey, the art director at Collins, the publishers, who were looking for a cover image for the soon to be republished paperback version of The Naked Civil Servant. Mike took an instant liking to the portraits and this book cover became my first ever published image.
Now it's in the National Portrait Gallery collection.

Heaven sent- Hell bent'
The idea behind this image is
'good and evil', with the left leg
representing 'HEAVEN'
the right leg, 'HELL'.

illustration

BBH/Vodafone, 'Many Cultures, One world'
This was created as billboard illustrating the
multi cultures and global reach of Vodafone.

NPC (New Philanthropy Capital)
A typographic illustration of a tree, with
labels, bringing attention to all of its dif-
ferent functions and benefits.

Illustration is a visualisation - such as a drawing,
painting, photograph or other work of art that stresses
subject more than form. The aim of illustration is to
communicate or decorate a story, poem or piece
of textual information (such as a newspaper article),
by providing a visual representation of something
described in the text.

A road trip across America, illustrates all the states.

All illustrations by Serge Seidlitz

Fields of Gold - BBC 1 TV
Animated Alphabet
The typeface was designed to be reminiscent of DNA coding (narrative related).
Unusually an animated alphabet was constructed with this project - each letter
was individually animated rather than blocks of type so it could be instantly typeset
animating this made it very versatile. - Peter Anderson

In *I'll walk alone - You'll never walk alone (walkalone-neverwalkalone.net)* at the
Harris Museum Preston I presented the film-strip photograph as a 43m, 360 degree
installation. In response to the museum's permanent installation of classical friezes
depicting figures of war, sport and games at the Museum I wanted to reflect on
a connection of these themes in contemporary society in my film-strip installation.
I took several photographs during games at the Preston North End Football Club,
the oldest league club in England. Highlights of the games are stretched out in
a temporal landscape capturing the energy and movement rather than details of
individual players. The players are visible from a distance but on closer observation
the imagery dissolves into an abstracted energy of the game and an emotional
energy of viewing the game. The viewer in the installation becomes the centre.
With this internal energy I am interested in the role of the individual within a game
4or war situation and the spectator's point of view and decided to connect the im-
ages with 2 song titles: *You'll never walk alone* and *I'll walk alone*. The song *You'll
never walk alone*, from the musical Carousel (1945), was sung at the first football
game in Wembley Stadium after the second world war to commemorate the death
of comrades. It has become a song of public emotion in football and the wider
society. It was, for example, sung spontaneously at the eve of Princess Diana's
funeral. One year before Carousel, the song, *I'll walk alone* was song by Dinah
Shore in the war film Follow the boys. It became a popular Second World War
song in England with its sentiments of spiritual togetherness. Sigune Hamann

*brainstorm

project sequences

images or text or combinations of text and image which move
Video is a time based medium. Compared to a photographic exhibition, where the
spectator moves around the gallery and chooses which image to look at, in cinema
and television it is the images which move while the spectator stays in one place and
watches x image in combination with x other images for x time, set by decisions
the film maker made in pre-production.

 With the possibility of control in time over the audience comes the responsibility
to devise timings to keep the attention and interest of the audience.

A story can be told chronologically, in reverse chronology, or in a non-linear way
through any inversion of time structure. Non-linear stories or narratives often have
an advantage by applying formal ideas of:

- jumps in time structure ie flashback
 (Kubrik: The Killing, Tarantino:Pulp Fiction, David Lynch)
- addition through repetition
 (Bunuel: The Exterminating Angle, Martin Arnold:piece touchee)
- addition of several different stories (Robert Altman: Shortcuts)
- addition of several different outcomes of a narrative (Kurosawa: Rashomon)
- split or multiple screen i.e. showing parallel scenes of past and future
 (Mike Figgis: Timecode)
- suppression: purposefully leaving out specific information in a linear structure
 (several thrillers)
- random programming to determine sequencing of narrative modules
 (Stan Douglas:Journey into Fear)

When you think about narrative time link it to the 3 time categories:
- order ie sequence of events
- duration ie how long in real time and how long in film time
- frequency ie how much repetition if any

Apart from the positioning within the film the absolute timing of each element has
to be considered including methods of punctuation/editing i.e. including pauses
in images (blank frames/in-between titles/freeze frames...) or sound and of reduction
or extension: (stretching material / speeding material up).

Consider also narrative perspective (camera angle, first or third person narration ...) and genre or style of film you are aiming for and why, and who your audience will be.

It is not always the intention of the film maker to mimic reality.
Continuing experimental use of film and video since the 60's has incorporated material experiments, multi screen experiments, multiple narrative experiments, time and space experiments, sound experiments, multiple monitors, multiple projections and multi-perspective narration, found image and sound, found film experiments, rhizomatic narration and image de/construction.

Create a 1 minute film by exploring the relationship of sound and images as equal media. Use sound as more than atmospheric background noise. Sound and images don't have to do the same thing at the same time.

Narratives are stories, or the combination of elements to form a story. it is also the basis of all literature, plays, film etc. It is the way we make sense of things, the stories we tell ourselves about the world.

Language implies narrative because we join things up to make sense.

To really begin to understand how communication operates in a 21st century setting we need to understand the forms and structures that underpin it, and what make it different to the 19th century. The beginning of this understanding is exploring the changes that have happened over the last century and to think about the theories there are about methods of communication.

Communication isn't natural and transparent, it is culturally determined.

The big words in Graphic Design we need to consider are: reproduction, aesthetics or style, audience, mass communication, myth, post-modernism, and hot and cold media.

Reproduction
The fact is all images are now endlessly reproduceable, mechanically, digitally, physically and immediately. This change in twentieth century media was accelerated by the invention of the moving image in 1895, and by the invention of TV in the 1930's. The advent of computers again changed the nature of reproduction. Visual culture becomes the dominant form again in the late 20th century and reproducibility inflects all communication. The reproduction of images also leads to their becoming familiar to everyone; so that the grammar of images changes in communication. The Mona Lisa is as familiar to people now as the Eiffel Tower, and both are used in marketing.

Aesthetics or Style -
What defines something as attractive, appealing or beautiful. This is the name that is given to the branch of philosophy, which seeks to deal with the idea of taste, or of discrimination, of art and artistic judgement. Everyone is always judging as to whether things are good, bad, ugly, boring, ridiculous or sublime; 'aesthetics' is the study of how or why they are these things. The Greek word 'aesthesis' meant perception, and the modern usage takes up that sense of the act of appreciating, of discriminating. Describing what is beautiful or worthy of praise has a long history in philosophy, which goes back to Plato and Aristotle but aesthetics as a particular sub-branch of philosophy is much more recent. The term was first used in its modern sense by German critic Alexander Baumgarten (1714-62) and he was interested in thinking about what made human creativity special. The philosopher Kant also developed this discussion of sensuous activity and considered the ways in which we decide what makes a successful work of art. Aesthetics also covers questions about the nature of art, how we define what is, or isn't art, what is artistic 'taste' , how we define beauty and artistic experience and what the philosophical and psychological problems are that such definitions give rise to. The real search is for what can be termed 'universal' ideas of beauty, things that can be shown to be somehow intrinsically beautiful, in other words 'objectively' so. It is here that aesthetics overlaps with ethics, where there is also an attempt to create universal standards.

signed sealed delivered I'm yours
stevie wonder

Many critics of this kind of 'universalistic' position would argue that aesthetic judgements are merely the expression of a particular group's views at a particular time, and therefore relative. When there is a dominant group in society, and that society is stable then the dominant group's aesthetic viewpoint will tend to appear as fixed and immutable, as for example with traditional historical painting in the 18th & 19th centuries in Britain. This kind of cultural domination is what Marxist critics refer to as an ideological discourse, in which a class interest is represented as the universal basis of all art. Whatever agreement there was in the nineteenth century about these things has gradually declined during the twentieth century as notions of art and and popular culture have come under critical discussion from many different theoretical viewpoints. At the end of the nineteenth century the term 'aesthetics' was taken over by the 'art for arts sake' movement, who saw elegance and refinement as an end in itself. Thus in Britain a slight derogatory sense of the 'aesthetic' as indulgence remains, mainly because of the connection with Oscar Wilde and his notorious claim that 'all art is quite useless.' We now tend to talk about the "aesthetic" of things as being the idea of its style, what it is about, like a "punk" aesthetic.

In Design people think about combining new elements to produce a new aesthetic.

Terry Lovell, Tania Modleski, Terry Eagleton, Toril Moi, Dick Hebdidge, Andy Warhol.

Audience

The assumed group to who mass communications are aimed.

Before the rise of mass communications the term simply meant the group of people to whom a performance was addressed, and by implication the audience were part of their process. The development of mass communication replaced this fairly close relationship with one of distance, power and impersonality, thereby changing the nature of the audience significantly. Early mass communications however thought of the audience as simply an agglomeration of individual viewers or receivers, and who were seen as fragmented and passive. In the era of mass communications almost everyone is part of an audience, and understanding the relationship between the communicators and the audience has become a central part of mass media studies. Historically media studies has theoretically had a 'top-down' view, which began with the broadcasters, considered the text or programme and often read the audience off as being simply an 'effect' of the process. The first major distinction that was accepted in terms of the audience was that between the 'audience' for public sector broadcasting and that for commercial broadcasting. Public sector broadcasting was seen as paternalistic, concerned with national values and civic virtues and therefore likely to seek a strong identification with the target audience (the-audience-as- public) The rise of commercial broadcasting was seen as creating a different type of audience that was concerned with entertainment, advertising and marketing (the-audience-as -market). The principles of these two different kinds of broadcasting were expressed as being on the one hand to serve (audience-as -public) or to sell (audience-

as-market). This rather simplistic model in media studies has been replaced by conceptions of audiences as being multi-faceted, diverse and more active in their de-coding and understanding of media cultures themselves. Both kinds of broadcasting are actively seeking audiences, and as the mass media multiply and change, so the assumed audience becomes an ever more complex reality. Many recent television shows now feature the audience as central characters in the programmes, and docu-soaps are also a new manifestation of the audience becoming a self-reproducing part of the mass media.

Audiences are now fragmented, multiple, global, massive, questioning, particular and very hard to understand.
Tania Modleski, Roger Silverstone, David Morley, Adrian Shaughnessy, Lawrence Weiner

Hot and cold Media
This is a set of ideas from a famous (some say infamous) media theoretician from the 1960's, Marshal Mcluhan. His ground-breaking book, Understanding Media: The Extensions of Man (New York: McGraw-Hill, 1964), looked at many aspects of the then just emerging electronic media. He was a pioneer in the sense that he thought about the impacts of media outside the box, and clearly understood that new media would change the cultural world we live in. The fact that this seems stunningly obvious to us now just indicates how right was about some things, like talking about the "global village" (the wired up society that is everywhere). Compare to this to the chap at the BBC who said in the 1950's "this television thing won't catch on it's too difficult too watch"

Mcluhan's distinction between hot and cold media is about the closeness of response that a particular media produces in its audience. A hot media is one that sensually gets straight at the audience, like the radio or television, which is emotionally appealing and direct. A cold media is one that is abstracted, complicated and requires the audience to do the work, like a telegram. Television is hot because it is emotional and visual, in your face, and maybe mobile phones are warm because they are intimate and immediate. His definitions, once you get past the obvious, start to sound a bit flaky, as media re always bound up with the audience's and cultures in which they operate, but he is definitely onto something. He also famously said the "medium is the message" which means something like, the way a particular media functions in society tends to determine the outcome of the way people experience it. That is to say that television is 'televisual' in the way it reconstructs the world, it makes the entire world like television. Again this is probably pretty true, just like computers tend to refashion the world after their own image, everything is virtual these days, even the real. This has a profound effect upon culture and design, which has to be thought about.

It is also a kind of technological determinism, that is an idea that the technology drives society and determines what sort of a culture we operate in, which greatly influences design and visual outlooks.

Mass Communication

The ability to communicate with a large audience, particularly electronically and thereby simultaneously.

This is a term that is very much of the twentieth century and many theorists argue that it is the defining term of the twentieth century. The terms mass media and mass culture are used within the same theoretical framework and refer to the means of mass communication and to the culture it produces. Some theorists date the start of mass communications with the invention of printing and the rise of the book in the fifteenths to eighteenth centuries, but this is not strictly accurate since it was not until the late nineteenth and early twentieth centuries that literacy was a wide-spread reality and thus enabled true mass communications. The rise of the mass circulation newspaper in the nineteenth century is the real beginning of an effective mass communication, where very large numbers of readers could be part of a simultaneous audience, and it was only with the arrival of radio that this trend became an actuality. Mass communications is an integral part of the process of industrialization and modernization that transformed capitalist societies during the last two centuries, and in its most recent phase, that of the globalization of culture, has assumed a pivotal role in defining social experience.

What are the characteristics of mass communications?

1 The ability to speak to extremely large audiences simultaneously, usually from a central point and to a wide-spread and fragmented audience. (From radio through Television to satellite television and global audiences.)
2 The technologies mass communications rely upon themselves impact upon the modes of communication adopted, particularly in the way that they centralise the dissemination of information.
3 Mass communication produces complicated formal organisations, from publishers through to television channels and newspapers.
4 Mass communication is public, and therefore creates a particular public space, which had not previously existed. Traditional face-to-face culture is increasingly replaced by anonymous, top down cultural forms isolating the consumers
5 The nature of the relationship between cultural producers and consumers, like a writer or playwright and their audience, is also transformed, often into a rela tionship, which is implied but not immediate. This is particularly true of television.

6 Because of the nature of mass communications the nature of the audience changes, from being specific audiences to that of being heterogeneous, a mass audience made up of very different individuals in different circumstances.

7 In mass communications the role of the communicator to the audience is unique, the communicator is only known through the public role and therefore relation ships of cultural dominance are likely.

8 Mass communications facilitate mass propaganda and thereby a transformation of the political, as well as the cultural, sphere.

9 The collective nature of the mass audience is unique to modern society, sharing an electronic intimacy in which common goals are pursued by individuals who are actually unknown to one another but act as though they form a conglomerate.

10 The electronic media, and particularly television, entirely dominate the symbolic economy of the advanced capitalist countries, and are redefining leisure, culture and transforming the nature of inter-personal relations.

11 Mass communication is seen in many theoretical models as manipulating the audience, as proliferating the ideologies of either the dominant classes or of capitalism. (Called 'ideological state apparatuses by Louis Althusser.)

12 The two main models of mass communication are state controlled mass media, as was routinely found in the communist countries this century, or commercially owned and controlled mass media, which has been the dominant American model. There has also been the public sector broadcasting model, most notably the BBC in the UK and similar organisations like the ABC in Australia. Generally these are semi-independent institutions meant to serve the 'public interest' but which have come under strong commercial pressure over the last decade.

The main theoretical approaches to mass communication are Communication studies, which are linguistically based, and which includes many of the model based theories of communication flow as well as Representational theories, which are semiotically based and which consider the construction of meaning in the mass media. There is also a large sociology of mass communications, which includes the Frankfurt School-based critique of the 'culture industries'. the political economy of the media, cultural studies approaches based on the analysis of culture and ideology and work based on discourse analysis and feminist critiques of media representations. There are also increasingly studies based in the analysis of popular culture, of audience modes of understanding media products and in postmodern studies of the forms of pleasure and play in television culture.

The continuing importance of the concept of mass communications is demonstrated in the fact that postmodernism as a theory is fundamentally based on the assumption, particularly argued by Baudrillard, that the electronic media so dominate society that there is nothing anymore other than 'hyperreality' . In other words reality itself has been wiped out by the

dominance of communications and thus to consider something outside this is to foster the illusion of the importance of mass communication is underlined by the fact that postmodern theory the 'authentic'. The theoretical weakness of this argument is fairly clear, particularly when Baudrillard famously claimed that the Gulf War didn't happen, it was just a media event. This kind of theoretical nihilism may reflect the fact that traditional intellectuals have been completely sidelined by media culture and are struggling to find a new role. Postmodernism mostly seems to want to avoid the problems of mass communication that deal with economic power, social organisation and political control, preferring to elevate the ideological and cultural realm to the status of a free-floating universe. From whatever perspective it is approached mass communication is clearly the single most important factor in a globalized, electronic culture.

Myth

The idea of myth entered English in the 19th century, and has since entered everyday language both as fable and as everyday urban myth. Its meanings are multiple and depend more and more upon the particular context in which it is used, it is, for example sometimes used in street speech as 'mythic' which means something like 'awesome'.

Its first historical sense was to refer to 'fabulous narration' or imaginative constructions, which were treated as historical myths or legends, its secondary sense was the critical idea of stories or legends that were untrue or untrustworthy, both of which have persisted. Myth has always been opposed to truth or reality, but there has been a tendency, which comes out of Romanticism to revalue myth as containing a higher level of meaning than everyday reality. In an interesting sense Levi-Strauss and Roland Barthes have maintained this notion of myth as somehow being a particular mode of thinking that is different to the ordinary.

Myth can be seen as narratives of origin, or in other words stories of the history of a culture. This is another way of saying that all cultures tend to create explanations of their becoming in order to justify their present, a kind of psychic fixing of cultural continuity by anchoring the present in the past. It is noticeable that all religions are heavily dependent on myth to sustain their ideological hold on the social patterns of communities. For Levi-Strauss myth was the mode in which primitive cultures thought their relationship to the world, to social relations, to marriage, and to death. Thus myth was centrally involved in the cultural reproduction of a societies basic functioning, and for Levi-Strauss the analysis of myth, and its structuralist patterns, was the central aim of Anthropology.

Roland Barthes famously updated Levi-Strauss's analysis of myth to consider the cultural and ideological forms in which popular culture operated in capitalist society. In his Mythologies (1966) he argued that 'Myth is a form of speech' , by which meant that myth was a particular way of understanding the world, and of expressing it, and also that myth appeared to be natural whilst in fact making familiar what was ideologically unnatural. Thus

for Barthes, as well as for Levi-Strauss, myth was a form of thinking that reconstructed the world in an acceptable fashion, whilst hiding the contradictions and repressions that were a necessary part of a partial world-view.

Post-modernism/postmodernity
The successor to modernism or
a new form of society, or a kind of post-structuralist philosophy.
This is one of the two or three most unstable terms in cultural studies and philosophy today, its usages vary from simply describing what comes after modernism in the arts, right through to a claim that we live in a postmodern world which is completely hyperreal. It is also a term that has entered the broader culture and appears to have taken on a life of its own, so that it is a term that is much debated in the academy, gets used in the popular press and apparently represents a particular new philosophical position. Jean-Francois Lyotard claims to have coined the word to describe the new post-industrial, post-fordist, communications-based society that we live in, and the way in which all knowledge and culture have been transformed . Or to put it more simply there is a movement called postmodernism which is evident in culture and the arts, and there is a theoretical description of society as being postmodern. The term actually appears to have been used in architecture first in the 1950's and 60's , and was taken up by Lyotard, who turned it into an anti-marxist and post-structuralist critique of science and society. His book The postmodern Condition: A report on Knowledge (1984) seems to have set the seal on his appropriation of the term and to mark the birth of the theoretical movement we can now call postmodernism. There are so many elements to the postmodern/postmodernism debate that it is perhaps best to list the stronger and weaker claims, the major categories within postmodernism and then consider whether they cohere into a definable theoretical position. It is necessary to point out that there is little agreement about what constitutes postmodernism, even as a theoretical position, but that one of the claims of postmodernism, that all theory occupies a relativist universe of possibility, means that even the grounds on which one would judge postmodernism are not clear. (This can be a strength in that denying any empirical reality means that there is no plane on which to compare the theory to a supposed 'reality')

Major features of postmodernism

1 Postmodernism is strongly anti-foundationalist. It denies, in other words, that there
 any foundations to the structures of knowledge upon which science builds its
 claims. It denies that there are objective scientific truths and rejects meta-theo
 ries that seek to explain how society, history or science works. This radical scep
 ticism about truth claims extends to the argument, which is central to post-struc
 turalism, that language is unable to represent the world, or that there is any fixed
 meaning or truth.

2 The rejection of attempts to make sense of history or progress, what are called
 'grand narratives' . is extended in particular to a rejection of the Enlightenment
 claims for the powers of reason, of science, and of scientific and technological
 progress. The Philosophers of the Enlightenment, along with Kant, Hegel and Marx
 are all chastised for their naive and imperialistic, all embracing theories of the world.

3 The rejection of large scale theories goes hand in hand with the celebration of
 fragmentation, difference, discontinuity and the ephemeral. Hence origins, conti
 nuity and unity in historical periods are seen as an illusion. This instability of mean
 ing of course makes it very difficult to characterise the postmodern period itself,
 but this is not seen as a problem.

4 There is an absolute rejection of meta-theory, like Marxism or structuralism, that
 seeks to explain the inter-connectedness of things, or to think of society as a to
 tality. It is claimed that meta-narratives are no more than the legitimation of hierar
 chical power structures.

5 Postmodernism seeks to consider the immediate, the local, the marginalised in so
 ciety, the 'micro-politics' of power relations, or the social fragments of alienated
 youth or marginal groups.(influenced by Foucault) There is an implicit stance that
 the local, the fragmented, the fluid, the ambiguous has a privileged place in analy
 sis. Postmodernism is pragmatic local and contextual.

6 Postmodernist thinkers, drawing on post-structuralism, reject the theory of lan
 guage, which claims that there is any correspondence between the signifier and
 the signified, between language and the world. For the postmodernists meaning
 is always deferred, fragmented, relational and non-referential, which leads to what
 is called a 'crisis of representation' Baudrillard also claims that the sign has been
 commodified, and that the signifier and the signified have collapsed into each

other, thus producing a culture in which there are only signs, there is no depth and there is no ideology, nor, in fact, are there any subjects.

7 The theoretical diversity of postmodernism makes defining it entirely elusive, so many of its claims to be anti-modernist simply repeat positions which are very sim ilar to the modernist avant-guarde, a term that postmodernism ignores, probably for that reason. There appears to be little sharp difference between modernism and postmodernism in terms of an attack on established values, in some forms of literary experimentation and even in attacks on traditional meta-narratives.

8 The individual in postmodernism as seen as an ideological structure, albeit one that has no false consciousness, it simply is consciousness, which is discontinu ous, fragmented and unstable. The subject is 'schizophrenic' but, in a typical post modern move, this is not schizophrenic in the clinical or classical sense (the ref erent) but more in the sense of a disturbed, fragmented personality. The argu ment for this position stems from the argument about language, which is, as we have seen, non- referential and non-representational. The chains of linked signi fiers that create meaning are seen as being disturbed and unstable, partly as a re sult of mass communications, and the subject is seen as unable to reconstitute these chains of signification, and is therefore doomed to wander around in a frag mented, confused, we might say, schizoid, state. All time is present, all meaning is simply the experience of the present, and all culture and psychic life are simply the mode of being of the mass-media. This is the 'society of the spectacle' as de scribed by Debord and illuminated by Baudrillard. (The fact that it sounds exactly like the rationalist meta-narrative of the Frankfurt School is a slight irony.) Further more it is never explained exactly when, and how this loss of meaning in commu nication suddenly occurred, and its occurrence implies that prior to this referen tiality did function?

9 Postmodernism exhibits a fascination with mass communication, with new tech nology, with mass communications dominating the economy (which is also fun damentally an idea advanced by the Frankfurt school.) and with the idea of an 'in formation' economy. Globalization, satellite and computer communication are all seen as aspects of the 'post-industrial' world that post modernism inhabits.

10 Mass communications and the collapse of meaning therefore produce culturally centered immediate consumption and sensationalized impact, with consequent loss of depth. Electronic communication immediacy ensures the surface of endless signification is seamless, and problems of meaning /analysis are endlessly deferred.

11 The dominance of electronic media, consumption and the society of the specta
cle has led to the decline of the distinctions between 'high' and 'popular culture',
to the erosion of the cultural authority of the elites and to the creation of a mass
consumerist populist postmodernism.

12 The populist market-place of electronic consumerism has become global and rep
resents a new phase in capitalist, or post-capitalist, development which is entirely
dominated by pleasure, spectacle, consumption, parody, pastiche, difference, frag
mentation and irony. (This is the weak version of celebratory postmodernism.)
Eurocentric and androcentric ideas are replaced by pluralist and progressive ideas.

13 Postmodernism in cultural terms, as for example in architecture, utilises popular
styles and formats, draws on many different sources and periods and plagiarises
effects and ideas from anywhere and everywhere. The obvious connection with
the way that many postmodern design and artworks raid many different sources
describes a cultural similarity, but the question remains as to whether this consti
tutes a new aesthetic.

14 Some critics, like Frederick Jameson, argue that what is described as is nothing
more than the cultural logic of late capitalism. In his work Postmodernism or the
Cultural Logic of Late Capitalism he argues that there is a culture that can be de
scribed as postmodern, but that this is no more than the commodified form of
mass consumerism and the domination of media industries that describe it.

The questions remaining unanswered in the postmodern pantheon are to do with per
odization and with social realities. That is when did modernity end and postmodernity
begin, and what caused the transition from one era to the next. Does postmodernism's
rejection of a known reality, of economic determination and of social structures lead it to
be unable to criticise social development, is it just a celebration of Anomie and consumer
identity.? Does postmodernism's rejection of sciences ability toengender human progress
lead it into intellectual nihilism? Feminism and postmodernism have developed an inter-
esting partnership in the development of studies of change, of changing identity and of
postmodern feminism, as with the work of Spivak and Butler, but the connections between
Deconstruction, post-structuralism and feminism are rather eclectic. As a theoretical move-
ment celebrating innovation, appropriation and the micro-analysis of social development
postmodernism clearly offers interesting modes of theoretical work, the wider questions
of its relationship to social sciences and philosophy we might say it sweeps under the his-
torical carpet throwing the rug of relativism over the gap.

Baudrillard, Lyotard, Butler, Spivak, Haaraway, Mcluhan, Kitler

what is a sign?

A sign is any object, mark or image that in some context can convey meaning.

All communication is about representation, about how things come to mean in a social context. Graphic design is the process of using signs to communicate.

Semiotics looks at signs in society

signifier/signified

Sign/Referent

Sign/Referent/User

The word (cow)

The animal (moo-ness)

The sound

Conventionalism

The "stand-for" relation

what is graphic design?

Graphic design constitutes a kind of language with an uncertain grammar and a continuously expanding grammar. (Hollis)

Only 7% of communication is verbal. (Morgan Stanley ad.)

Words are things that represent other things.

Signs are how we understand the cultural world around us.

stand-for relation

Signs/images/words "stand-for" (represent) other things.

Maps are semiotic par-excellence

The universe is composed of signs

semiotic irreducibility

Everything is connected

Signs don't mean on their own

It is the relation of one sign to another that gives it meaning

Signs are arbitrary

Codes govern the meaning of signs

Signs are conventional (agreed by users)

Signs may be polysemic

what are languages?

Words/images

Rules

Grammar

'The whole body of words and methods of communication used by a nation, race or people'

Verbal/visual languages

semiotic terms

Langue/Parole

The system/the spoken

Syntagmatic/Paradigmatic

S = Combinations to form larger units

(poems/sentences/codes)

P = Contrasts & oppositions

(dog/bog/fog –– dead/alive etc)

transmission/sharing

Codes are organised patterns

of recognition.

Highway code – set of rules & patterns

of behavior.

Meta-codes = ideology

semiotics = structure

binary oppositions

White = not-black

Male = not-female

Alive = not-dead

Scruffy = not-smart

Things only mean something

in the system of codes

semiotic readings

What do things represent

Do they connote or denote (or both)

How do signs work in advertisement

What codes do we use (unconsciously)

What does fashion mean?

How do clothes signify?

How/why do we read clothes

and contexts?

denotation/connotation

Denotation = the literal

(3 blokes & a woman)

Connotation = religious tale

of mystic martyrdom

advertising = mythology

Advertising mobilizes signs

Codes are how signs are locally

organized

Every element in advertising

is motivated

Dream work = signs

theory

diagrammatic representations of communications models

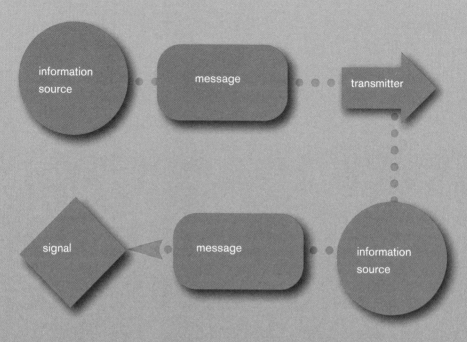

linear model (Weaver)

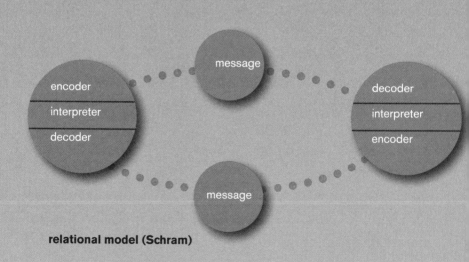

relational model (Schram)

project

Using illustration, drawing, photography, animation, sound etc. select and record five similar objects (for example shoes, perfume bottles, cars, jackets, cigarette packets, boxer shorts, pens,buildings, dogs, beer bottles, etc, etc) and analyse their image, their design, their 'semiotic'. Consider the relationship of design, image, colour, context, reference and "coding" What signification process is going on, and how?

Compare and contrast the different objects but we want you to analyse the kind of meaning that these objects convey, and how they do it; the central question to be addressed is 'how do objects convey meaning in a cultural context?'

Reproduce the objects in whatever media is appropriate and 'deconstruct' how the image works, and possibly add a commentary on how such objects 'semiotic' could be improved. It is important to record the methodology used to analyse the 'meaning' that objects acquire.

project

Select an advertisement, image or film clip and develop a theoretical analysis of the meaning systems of that image, clip etc utilising one of the theoretical models studied during the unit, alternatively, develop an alternative theoretical model of communication and demonstrate its viability. What's being asked to think about is - how the image, narrative or text conveys meaning, to consider it's 'social semiotic.'

www.lineto.com (type)
www.brucemaudesign.com
www.visit4info.com (advertising resource)
www.eyemagazine.com (archived articles)
www.davidshrigley.com
en.wikipedia.org/wiki/main_page
www.guardian.co.uk

brandmaster flash

'who are you going to believe, me or your eyes' – Groucho Marks

The well known Graphic Designer Tibor Kalman summed up the changing role of the brand this way: "The original notion of the brand was quality, but now brand is a stylistic badge of courage." (Naomi Klien - No Logo)

Graphic Designers are employed to create and implement brand ideas (client visual mediation systems for client defined audiences).
These ideas are informed by and invariably initiated by marketing process.
How does the designer engage and influence the marketing process. - Let's see how marketing works

Designers mediate/initiate messages to a predefined audience (many years ago the only available media were print, television and film, making the delivery of messages very circumscribed. England had only 4 TV channels for companies to deliver awareness of their products, and limited print outlets. With the advent of pay TV, satellite, cable and huge advances in digital technology and printing processes, and materials, the delivery of messages has become diverse and fragmented. For advertisers using TV this is a huge headache. Agencies cannot accurately guarantee to their clients that viewers will be on receiver mode ie in front of their TV sets when they want them to be. Advertisers, marketers, pressure groups, artists, governments, local councils, etc are all constantly trying to secure our attention however the variety of media options available make this very difficult.
We live in a fragmented media society. This is can be very liberating, we can initiate and innovate all sorts of unexpected ways to reach and influence the audience/market. Designers need to become risk takers, entertainers, teachers, crystal ball gazers, visualisers, financial managers, problem solvers, experimenters, communicators, market makers, inventors and quizmasters, in short they must learn to recognise no boundaries.

photo: Dod Miller

marketing - what is it?

<div style="float:left">

Understand the
principles of marketing
and how to
use them to **win**

The Four P's
are your key **levers**

Your Marketing Mix is
how you **choose**
to use them

Marketing is about
increasing your chances
of **winning**

**winner takes
(almost) all**

noise! noise! noise!
noise! noise! noise!
C U T THROUGH
noise! noise! noise!
noise! noise! noise!

</div>

*"Marketing is the way in which any organisation or individual
matches its own capabilities to the desires and identified needs
of its customers."* Andrea Sanders Reece

Failure to successfully connects often results in the failure
of the organisation or individual.

what does it do? (function)

The marketing function is carried out against a dynamic
environment which includes: direct and indirect competition

e.g. luxury round the world holiday
 direct competition - other luxury holidays
 indirect competition - new car, new kitchen
 economic uncertainties

e.g. rise in oil prices
 legal constraints

e.g. cannot sell alcohol to under 18s
 political constraints

e.g. ban on English beef sales to France

how does it function?

The marketing function plans, co-ordinates and controls
the four P's:

Product or Service
Price
Promotion
Place

Whether or not an organisation has a formalised marketing
function, the matching inevitably has to take place for the
organisation to exist.

Product Life Cycle

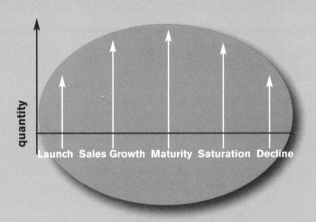

quantity

Launch Sales Growth Maturity Saturation Decline

You have no right to
life, health, food, sex, work or money

You only have opportunities

It's a competition
(winner takes all)

Product or Service

Product:
A thing produced e.g. vacuum cleaner, cabbage, bottle of beer

Service Products:
A series of benefits that cannot be stored e.g. train journey, hotel room, cinema visit

Product Services:
Products are often sold on the basis of before and/or after sales service e.g. cars, washing machines, PCs

When matching is successful and communicated effectively product sales tend to grow slowly and steadily during the launch period.

Once established, early users will begin to repeat and promotion will encourage new customers. At this stage growth is rapid.

Competitive organisations will imitate the product and increase the overall promotional spend, further accelerating sales.

Ultimately the rate of sales slows as the product moves through maturity.

As the product or service reaches saturation the only way to halt the inevitable decline is with product modification, price changes or change the product distributed.

Agenda
- Brand
- Bandwith
- Promotion
- The Power of Ideas
- Idea Test
- How to Sell an Idea

Good Ideas
- Connect because they are based on insight
- Are distinctive/proprietary to the brand
- Replicate across media and time

Brand
- What is a brand?
- How are brands born?
- How do they survive?
- How do they die?

Promotion
- Being interesting/useful
- to the right people
- at the right time
- in the right place
- in the right way
- for the right reason

Idea Notes (1)
- Sometimes the product is the idea
- Don't wrap a good idea in a weak idea
- One idea is enough
- People remember ideas better than they remember things

Price

Different ways to calculate the pricing of a product or service:

cost plus pricing:

Simply expressed: Fixed costs (overheads) + variable costs (unit cost of producing each product) + profit = price

market pricing:

Price according to where the product is to be positioned in the market place - if this does not produce an acceptable level of profit, need to find out why

skimming pricing:

Launching the product at a high unit price to maximise return on investment and then gradually lowering the price

penetration pricing:

Launching at a low price to maximise sales and then gradually increasing the price

loss-leader pricing:

Launching a product at cost or with reduced profit which relies on its use by another product that has a much higher profit margin
e.g> *Wet shave razors are relatively inexpensive, the disposable razor blades needed to use with them are relatively expensive*

Place

Where the matching process takes place between the organisation and the customer and how the product or service reaches that point

 www.com
 retail outlet
 door to door
 tv only
 mail / telephone order

The cheapest distribution channel is not necessarily the best for the organisation.
eg> the more sales stages a product goes through the more diluted and/or distorted the sales message may become.

Who are the Customers?

Organisations need to decide who's want and need will match the product or service.

Customer Profile

Age Income
Employed / unemployed Employment type
Behaviour / Social Standing
Hobbies and Interests etc. etc.

There are several research methods used for analysing customers and their markets these include ABC and Mosaics.

abc

A B C1 C2 C3 D E
classifies by social class and income
ABC1 being the people with the highest incomes,
the professions and upper middle-classes

mosaics

classifies by 12 lifestyle groups and 52 types:
High Income Families (9.9%)
Suburban Semis (11%)
Blue Collar Owners (13%)
Low Rise Council (14.4%)
Council Flats (6.8%)
Victorian Low Status (9.4%)
Town House and Flats (9.4%)
Stylish Singles (5.2%)
Independent Elders (7.4%)
Mortgaged Families (6.2%)
Country Dwellers (7.0%)
Institutional Areas (0.3%)

Through Mosaics it is possible to acquire very specific data for customer profiling.
With a customer profile it is possible to design an appropriate communications strategy.

Idea Notes (2)
- Execution is not an idea
- An idea connects with brand content
- Strong idea, long campaign

Good Ideas
- Connect because they are based on insight
- Are distinctive/proprietary to the brand
- Replicate across media and time

Brand
- What is a brand?
- How are brands born?
- How do they survive?
- How do they die?

Brand
- What is a brand?
- How are brands born?
- How do they survive?
- How do they die?

Brand
- What is a brand?
- How are brands born?
- How do they survive?
- How do they die?

Communicating with Customers

Most straightforward is a representative of an organisation face to face with the customer e.g. a farmer's market selling produce directly from a stall by the side of the road.

More likely indirect communication:
Product or Service itself
Packaging - not just boxes!
also cinema foyer, signage, Virgin VIP Lounge etc. etc.
Advertising
Pricing
Public Relations / Media Relations
Point of Sale Displays
Leaflets & Literature
Exhibitions
Sponsorship
Product Placement
Website - direct and/or indirect

Need an integrated communications strategy

Design/communications mix

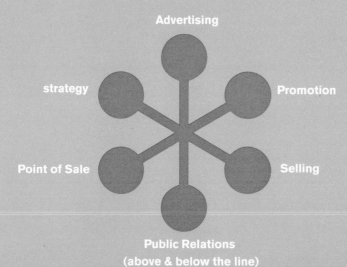

Advertising
strategy
Promotion
Point of Sale
Selling
Public Relations
(above & below the line)

Designing a new corporate identity for an organisation:

1. **Budget**
 How much is the organisation prepared to spend on designing
 a new corporate identity?

2. **Brief - As detailed as possible.**
 Why a new corporate identity?
 When is it to be launched?
 How will it impact on the organisation?
 What do they want to achieve by the new identity?
 Where will it be used, applications - buildings, transport, promotional
 materials, stationery, signage, product packaging, uniforms etc. etc.
 Colour / Black and White
 Internet / web page use
 Customer profiles
 Product profiles, current and in the future
 Organisation short, medium and long term plans

3. **Research**
 Organisation history
 Qualitative:
 what do all levels of employees think of the organisation?
 what are the customers and suppliers perceptions of the organisation?
 who are the competitors?
 what is the market place like in terms of size, value etc.?
 customer profiles?
 have the values of the organisation changed?
 how does the organisation sell its products/services?
 strengths & weaknesses of the organisation

4. Present research findings to the organisation with preliminary ideas
 for development of new corporate identity.

5. Design new corporate identity and check it works on all applications

6. Research new corporate identity with employees, customers and suppliers
 Does it match the original brief and objectives?

7. Produce a corporate id manual which details how the id should be
 applied and used throughout the organisation

8. Invoice the organisation as agreed

NB. Corporate identity is the total way an organisation presents itself to customers, suppliers and employees. How the telephone is answered, the reception area, staff outside smoking etc. All have an effect on the perceived image of the organisation.

creating an advertising strategy

1. **Background Research**
 - The Market
 - Brand Position
 - Competition
 Advertising
 Product/Service
 - Distribution
 - Consumer Motivations etc.

2. **Advertising Objective**
 - To build sales in the short term
 - To build reputation in the long term
 - To maintain price differentials
 - To change opinions
 - To motivate sales team

3. **Target Audience**
 - Demographics
 Age
 Sex
 Class
 Geographic
 - Psychographic e.g.
 - Active sport enthusiast
 - Vegetarian

Intended Consumer Reaction

Currently thinking ---------------------------------------> think in the future

Currently do ---> do in the future

4. Consumer Proposition

The one thing that can be said about the product/service that will affect the target audience in such a way that the advertising objective is achieved.

5. Support

Anything that makes sense of the consumer proposition or brings it to life.

6. Tone of voice
e.g. Nike "Just Do It"

7. Guidelines
- Advertising regulations
- Client stipulations
- Other Important considerations

8. Assessing an Ad
- Does it clearly say what you intended it to say?
- What is it advertising?
- Is it accurate?
- Does your target audience
 - understand it?
 - notice it?
 - like it / react to it?
- Will it offend anyone?

Advertising

media types
Television Radio Colour Press National Press
Regional Press Specialist Press
Outdoor Cinema Internet Public Transport
Shopping Trollies Parking Meters
Tickets Theatre Programmes

Television

strengths
98% penetration
mass-market medium
can target specific consumer profiles
impactful
intrusive
regional flexibility
staff/trade motivator
it works

weaknesses
expensive in capital cost and production

Radio

strengths
immediacy, can be on air next day
young audience bias - 16-34
locally available, can reduce wastage
flexible
strong local sense

weaknesses
not visual
secondary activity, usually background
complicated rate card structure

Colour Press

strengths
readership profile accurately assessed
wide choice of publications
cost effective
national coverage
tactical positioning available

weaknesses
long lead times in terms of copy
and financial commitment
regional variations expensive (inserts)
regional readership bias
large issue sizes reduce impact
long time to build coverage
high advertising / editorial relationship
around 60 / 40

National Press

strengths	weaknesses
mass coverage	limited regionality
national coverage	reproduction problems
cost effective	creative limitations
relatively accurate targeting	retail dominated, particularly
short lead times	Thursday & Friday
can give detailed product information	
immediacy	
colour opportunities	

Specialist Press

strengths	weaknesses
accurate targeting of opinion formers	advertising clutter
cost effective	may not be consumer biased
national coverage	
ideal editorial environment	
trade contact	

Outdoor

strengths	weaknesses
impact - largest ad spaces available	quality variable in location
creative opportunities	and number of sites
cost effective	production can be expensive
lower capital costs	
regional flexibility	

Cinema

strengths	weaknesses
young profile	young person's medium
captive audience	block presentation (13 min ad reel?)
impact	slow coverage build
style / image	limited audience research
regional flexibility	high production costs
excellent reproduction	limited availability
audio/visual colour	

potential client questions

If you are not presented with a brief for a project, here are a few questions to ask the client:

1 What is the product or service?
 How does it fit within the organisation?

2 What is the recommended retail price?

3 How does that price compare to other products in the market place?

4 What is its USP (Unique Selling Proposition)?

5 What is the life expectancy of the product?

6 Who are the potential customers?
 Try and get a detailed customer profile.

7 What is the project?

8 Do you have a corporate identity manual which specifies size, colour of logo etc.?

9 What is the budget for this work?

glossary

ROR	*return on investment*
rate card	*cost of advertising in the media*
cmo	*chief marking officer*
crm	*customer relations management*
CPM	*cost per thousand impressions*
USP	*unique selling point*
SWOT	*strengths, weaknesses,opportunities, threats*

communications strategy

questions check list

some questions relevant to a design project

1 define chosen subject and what are the reason for choice of subject

2 who or what is your market/audience?

3 what research do you require?
 gather market/audience research
 ie: facts/figures
 ie: create questionnaire (if required)
 ie: evaluate history of subject
 ie: create list of who to contact
 SWOT test
 STRENGTHS • WEAKNESSES • OPPORTUNITIES • THREATS

4 explain rationale for media/medias chosen to communicate your subject
 why chose those particular media
 how much does it cost - TV, magazines, radio, rate cards etc

5 define a mission statement for your chosen subject

6 prepare indicative creative work - rough ideas for posters, TV ad,
 sound, packaging etc.

7 LOGO
 design corporate identity (logo) if required
 explain reasons for logo
 explain how logo will be implemented and guidelines for usage of logo

8 decide on presentation media eg powerpoint presentation,
 A4 typed document, video, director movie, portfolio

9 timetable for preparation of work

10 get paid! or get laid

no context
no meaning

no meaning
no context

context

The dictionary defines 'context' as: the circumstances surrounding an event or fact which help make it's meaning clear. Where text is concerned this often means who:-

said/wrote/recorded it?
when/where/why did they do this?
when/where/why/how is it being presented to the reader now?

What the reader believes about these circumstances will greatly effect how they respond to it – e.g. whether they trust or mistrust, are angered or amused by, the concept the text is intended to convey.

Without precise control over context – the message underlying a piece of text is at best weakened, and at worst misunderstood.

As designers, we try to suggest context (and as a result meaning) through the visual characteristics of text as it's presented to the reader.We choose these characteristics for the associations we believe they will hold for reader, they are the subtle layered clues which combine to suggest the who, where and why of the message.

Think of it in a similar way to the effect your vocal volume/intonation, environment you're in, and social and cultural relationship might have when you say something to another person.

types of context:

commercial
advertising

non commercial
academic
papers
education
lessons, health
informational
publishing
news
interactive
independent

cultural

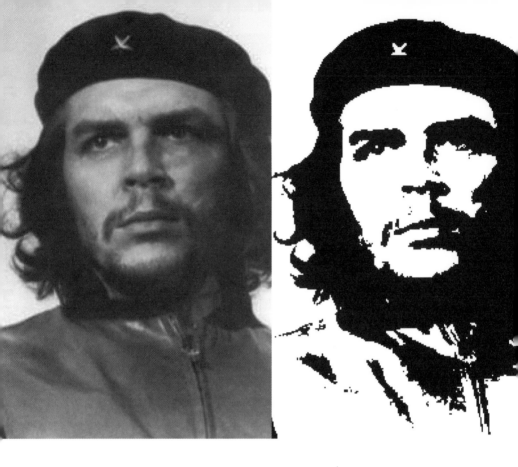

what happens when an image is located in different contexts?

This photograph of che guevara is probably the most recognised and most used
photograph ever. Cuban photographer Alberto "Korda" Gutierrez' (1928-2001)
photographed che guevara, at the memorial service for the victims of the
5 March 1960 explosion of the Belgian arms transport "La Coubre" exploding
in Havana harbour, killing 136 people.
Depending on the context, the photograph takes on various meanings from the
original newspaper/reportage purpose confirming Che's presence and solidarity at an
important event used for political purposes ie: propaganda.
In a fashion context where it's used on t-shirts, baseball caps it signifies radical cool.
In youth culture, such as the immensely popular student poster it represents angst, anti
hero, against the current government. In the Music industry such as Madonna's record
it associates Madonna with equality, civil rights etc. In drinks advertsing such as the
famous or infamous Smirnoff Vodka advertisement associates virility, independence,
fertility and male power. Our reading of the image will alter depending on the context.
It's the context which determines the meaning. Manchester born designer Peter Saville
used this technique of appropriation - using established imagery in unexpected contexts
regularly for designs for Pulp, Factory records, Hacienda, Joy Division. Images and text
messages placed in a unexpected context reaffirm their original message but also
provide a new reading of the message or image.

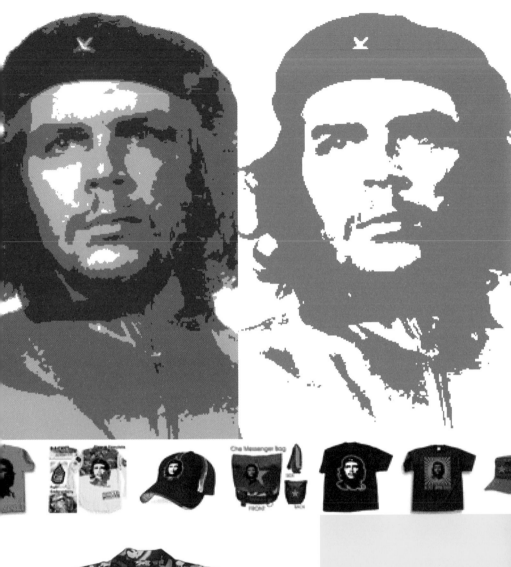

POSITIVE+ **wagamama**

DEPARTMENT OF ENERGY™

wagamama
POSITIVE

wagamama - a spoilt child - a great place to eat - a record company

wagamama is well known as a global concept restaurant with restaurants through-
out the world. It was created as an antidote to all forms of fast but poor nutritional
food, and the 'expensive therefore must be best restaurant ideas'.
It began it's extraordinary life as a concept with a very special context. The concept
was born during the 1986 oil crisis which produced economic recession in England.
and the world's economy experiencing financial melt down. In England interest rates
were 15% and rising. Money to start new businesses and try new ideas had run out.
'Money's too tight to mention' was a big hit tune at the time. The creators were driven
to ask the question what is the real way people use restaurants. So instead of trying
to find simply a new restaurant idea the creators thought what would be an all
empowering concept whose performance might be a restaurant, choreography,
music label, product range etc.

Try to create a paradigm shift, an entirely new concept.

Transparency, that is putting on show all aspects of the restaurant, ensuring
customers could see for themselves what the ingredients were and how they were
prepared was paramount in establishing a partnership with wagamama's customers.
The genesis of the name is a reference to China's one child per family policy where
Chinese parents predicably doted absolutely on their one child and treating them as
the most valuable thing on earth. The children were often referred to as **wagamama**.

The concept wagamama or **spoilt child** became the DNA and guiding principle.

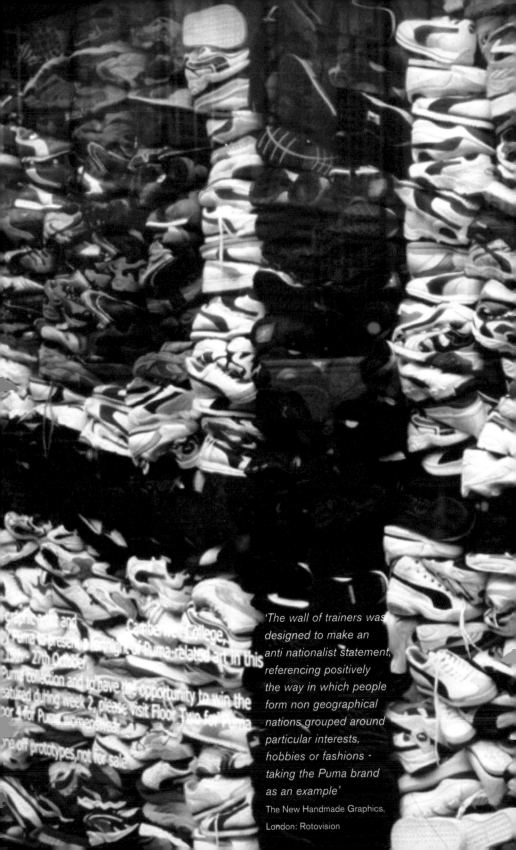

Graphics and [...]
a Puma [...] Camberwell College,
[...] 27th October.
Puma collection and to have [...] opportunity to win the
featured during Week 2. Please visit Floor Two for Puma
or 1 for Puma womenswear.
[...] prototypes, not for sale

'The wall of trainers was
designed to make an
anti nationalist statement,
referencing positively
the way in which people
form non geographical
nations grouped around
particular interests,
hobbies or fashions -
taking the Puma brand
as an example'
The New Handmade Graphics,
London: Rotovision

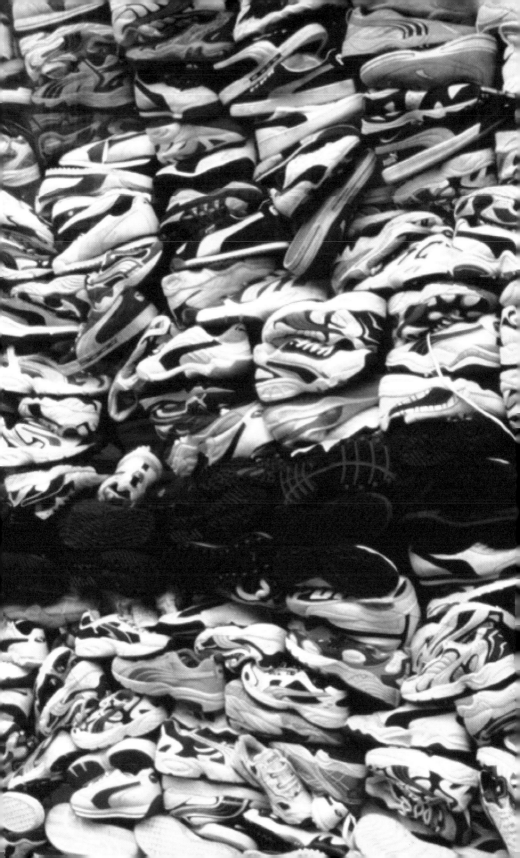

He ope
his mo
wide a
swallo
the th

channel 4 rebrand

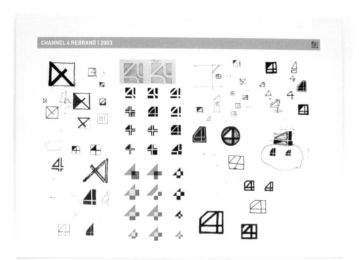

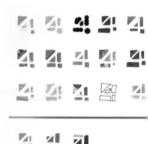

channel 4 rebrand

One such happy marriage has existed between Channel 4 and our company, Rudd Studio, for the last five years or so. We have designed or contributed towards the design of many parts of their ever-increasing family, including Film4, E4, 4Radio, 4 On Demand, 4+1 and Channel 4 itself.

Work started on the most recent rebrand of the main Channel in early 2003. There followed a long process of research and development, leading to the launch of the rebrand on New Year's Eve, 2004.

The beginning of this process involved a good look at the Channel's 20 year history. We realised that Channel 4 was an institution for which people had a lot of good will. Its original values - edgy, boundary-pushing, independent - were still felt to be present. However, these values were perhaps best represented and asserted by the original 1982 Robinson Lambie-Nairn Channel branding. The first Channel 4 idents - which were created using vast Cray super-computers at a company called 3i in Los Angeles, represented the patchwork logo in its most natural state - as an iconic 3D object which was centre-stage. The logo itself was the crux of the brand, not an apologetic adjunct to it.

So Channel 4 Creative Director Brett Foraker started the 2004 rebrand with a mission to produce a 21st Century version of the original 1982 brand. The process began with Brett developing the live action idents. Rudd Studio were then brought in to help develop everything else - the look of the print work, a new version of the print logo, on air menus, opticals and promo packaging. There was a serious look at whether the time had come to create a brand new logo. The original logo was now 20 years old and it would have been very Channel 4 to say 'new millenium, new logo'. We worked up two new logos which were both made from multiple parts. But when we placed these into the live action idents, we found that the moment of clarity was much less satisfying than with the Lambie-Nairn logo. It dawned on us that people's feeling of goodwill and warmth towards the Channel was very wrapped up with the logo. To find an amazing new way of representing the logo was going to be more powerful than replacing it.

The first big channel brand that I was involved with was E4. I'd always been inter-ested in hidden power of typefaces to establish an appropriate and unique tone for a brand, and I asked Jason Smith of Fontsmith to create a typeface for the channel. I think even those who had originally been asking 'what's wrong with a font off the shelf' came to see how this played a valuable role in creating the channel's tone, and therefore there was no doubt about the need for a typeface for the main

Ventures

Channel's rebrand. This presented more of a challenge than the E4 typeface, since Channel 4 could have a comedy like Ali G and a documentary about 9/11 on the same day. So we worked for a long time to achieve a font that was authoritative, distinctive and contemporary; one that had enough youthful energy but was not overtly trendy. As with all aspects of the rebrand, we were aiming to make some-thing that would last a few years.

There are many cases within design where financial restraints have lead to positive outcomes - the duotone colours of the Bluenote Records sleeves for exam-ple. But there are also cases where clients with deep pockets have allowed creatives to push new boundaries and move things forward. This happened with the original Robinson Lambie-Nairn idents in 1982, and also with several aspects of the latest rebrand. The on-screen menus emerged from a feeling shared by Brett and myself that in the age of digital tv, people were being bombarded with too much informa-tion, and were struggling to digest it. We decided to make a system where we appeared to 'drop in' on a section of the schedule, and focus one by one on up-coming shows. I worked this out on my computer with Flash, but then we had to embark on a six month process with the software developers for Clarity - the sys-tem used by C4 to generate their daily graphics - so that these menus could be made easily and quickly every day. This process could not have happened with a less wealthy client!body copy
- Mathew Rudd (Rudd studios)

JAZZANOVA 3 x 12"
That Night/Days To Come" (JCR records)
The whole project started with the search
or a logo for Jazzanova.

350 gr. sleeve with flaps on the outside, printed
in 4 colour and varnish

We thought the logo should be strong not only on printed matters, but also when
it is used in space, such as in our projections accompanying Jazzanova's sets when
they perform in clubs. So we designed 3-dimensional letters out of wire, thinking
of them as objects to be hung, lit, photographed and filmed from different angles,
leaving endless room for play. The actual play with the lines would become the
identity, rather than only a final and single readable sign.

Then, for a series of three 12inches (the 2nd and 3rd being remixes of the 1st.),
we decided to follow the first one (with the letters as the cover) on its journey from
the record shop (2nd 12inch) to the the record player at home (3rd 12inch).
The initial record (1st 12inch) would be highlighted in spot varnish to emphasize it.
Julie Gayard Jutojo design group

muse - City of Delusion

EAT, SLEEP, REPRODUCE, WORK, BUY, CONSUME, OBEY.
These are the laws of the city of delusion.

The **city of delusion** *is built of non descript white blocks, surrounded by a mass of polluted marshes and factory smoke. The inhabitants of the city of delusion are faceless drones who are constantly disrupted by there ever-changing cityscape. One single drone escapes the shackles of his suppressing existence discovering the true workings of his city that founded on corruption and mass control.*

City of Delusion was done on a tight time frame (the total for both films was less than three weeks), 4 days start to finish. Determined not to produce an animation wholly in the computer, we consolidated ideas by building a city scape out of wood, then shooting it on a green screen. We also filmed our girlfriends, brothers and Dougal pissing around in black boiler suits through the nights, then arranged these in a 3D environment along with photos of clouds and marshland.
The result was a disconcerting mixture of techniques, which though with a few glitches is still on tour with the other film.

PROJECT: MUSE 2007 World Tour Visuals
BRIEF: Produce visuals to accompany the band on their new world tour, for two tracks
(Butterfliesand Hurricanes / City of Delusion)
CLIENT: The Agency
PRODUCTION PROCESS: HD footage, After Effects, Final Cut.

process - starting points - concept development

WalkRide

Project title: WalkRide identity
Client: Newcastle City Council & Gateshead Metropolitan Borough Council
Design: Cartlidge Levene & City ID
Completion date: July 2005

Project summary
WalkRide is an information and movement identity for NewcastleGateshead that seamlessly combines information for both pedestrians and public transport users in the city. The first phase of the project just been completed and includes the livery and all related information for a new city centre electric bus system - QuayLink - and a new WalkRide city centre map for pedestrians. Cartlidge Levene collaborated closely with wayfinding and mapping specialists City ID from early concepts through to finalised design.

The identity reflects the distinctive culture and heritage of NewcastleGateshead while providing the flexibility necessary to express everything from complex practical information such as maps and bus timetables to more expressive elements such as bus liveries. The project was approached from the user's perspective, providing information in a clear, simple, intuitive manner.

The QuayLink buses are clean, bright yellow to cut through the noise of the city. Every aspect of the bus design was considered, from seat fabric to on-board maps. At bus stops, route maps are presented 'heads-up' giving users navigational information from their point of view so they can easily make the decision whether to 'Walk' to their destination or 'Ride' on the QuayLink bus.

We were commissioned to develop a new map for the city to be distributed by the local Visitor Information Centres. For the pedestrian 'Walk' map, careful editing of information and a simple typographic hierarchy provides a balance between richness and legibility that helps make it approachable and friendly. Illustrated landmarks are used as engaging elements to draw the user in. On the reverse 'Ride' side of the map transport information is presented in a clear, simple manner to make the information as useful and digestible as possible. 'Here' and 'There' stickers were produced as a tool for use by the Visitor Information Centre staff to point out destinations and routes to visitors.

design process

WalkRide

implementation - process

WalkRide

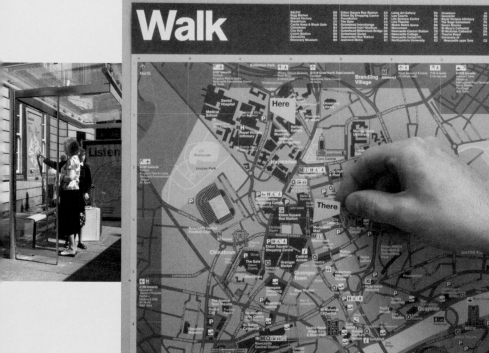

Concept sides
 front & back

Specification

item	colour	material
base colour	**electric yellow**	**Paint**
item	colour	material
vinyl	**white, reflective yellow**	**3M vinyl**

ildhall
towards Gateshead
towards Ouseburn

Guildhall
Q1 towards Gateshead
Q2 towards Ouseburn

Scarlet Projects and the V&A present

Village Fete 2005

MARTIN TICKNER & SEAN MCLUSKY

JOHNSON BANKS

JON HARES & ALEX RICH

FUKE

FLYAWAYS

MULTISTOREY

TATTY DEVINE

DANIEL EATOCK

SHIFT

HAPPILY EVER AFTER

A PRACTICE FOR EVERYDAY LIFE

ROB RYAN

NEW FUTURE GRAPHICS

PEEPSHOW

ARASH KAYNAMA & KELLY SAMI

DIGIT

JIM FIERCY

ATELIER

MOSLEY MEETS WILCOX

MICHAEL MARRIOTT

ABÄKE

ANTHONY BURRILL & MALCOLM GOLDIE (BAD ACID)

KERR|NOBLE

DEAR DAD

LIZZIE FINN

PARK

MARK PAWSON

THOMAS MATTHEWS

MULTISTOREY

CARL CLERKIN & GITTA GSCHWENDTNER

SCARLET PROJECTS

CHERIE YEO

ALEXANDRE BETTLER

PEOPLE WILL ALWAYS NEED PLATES

VILLAGE FETE 2005 –
Scarlet Projects and Victoria and Albert Museum
Each year the V&A museum and 'Scarlet projects' ask 30 different designers,
architects and studios to exhibit a stall in the museums' garden. In 2005 they asked
us to design a poster and booklet to promote the event. Our inspiration for the
events' identity came from fond memories of our childhood of traditional village fetes
in the english countryside. Often they held competitions such as 'most freakish
vegetable' or 'prize winning fruits'. For the 'Village Fete 05' we created a freak fruit
or vegetable to represent every designer/ or studio and used these to make up
a poster of stallholders. Alongside the poster there was a Judge's Guide for every
visitor to the fete – in this way, everyone could walk around the stalls taking notes
and judging the work for themselves.

DANIEL BUREN —
INTERVENTION II WORKS IN SITU
Modern Art Oxford, Oxford

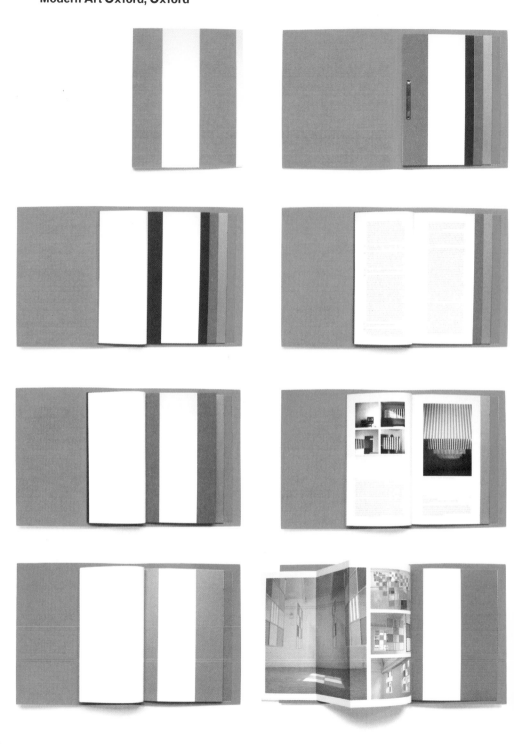

Modern Art Oxford asked '**A Practice for every day**' *to design a publication for artist Daniel Buren's exhibition. Our challenge was to create a publication which would be ready for the opening night. Daniel Buren always creates 'Work in situ', so he would be finished installing his work only one day before the opening, but it was essential that the installation photos would be in the book. A way in which we could condense time, was to avoid binding the publication (which would take several days of production time) and put it together on the day of the show.*
The initial idea was to create a simple folder with inserts and papers which could be printed before the exhibition with the installation photos printed and collated at the last minute.
An archive folder suited the language of the content of the publication - documentation of the exhibition and an archive of all of his UK works.
We considered the typical properties of these sorts of folders, the colours, shapes, materials and forms and saw them as opportunities to highlight ideas in Buren's work. The design was born out of the constraints of Buren's infamous 8.7cm stripe featured in the majority of his works, and the required number of sections and dividers for the content. The stripe cut through each section and decided the overall size, and the colours of the dividers, chosen with Daniel are configured alphabetically – the project was a brightly coloured mathematical challenge of simplicity and purity.

PETER ANDERSSON
LENA BERGSTRÖM
SARA BERNER
THOMAS BERNSTRAND
CLAESSON KOIVISTO RUNE
BJÖRN DAHLSTRÖM
MONICA FÖRSTER FRONT
MIA E. GÖRANSSON
ANGELICA GUSTAFSSON
MATTI KLENELL
ANNA KRAITZ
JONAS LINDVALL
ANDERS LJUNGBERG
ANNA KRISTINA LUNDBERG
MÅRTEN MEDBO
GUSTAF NORDENSKIÖLD
INGEGERD RÅMAN
KJELL RYLANDER
GUNNEL SAHLIN SALDO
PER SUNDBERG
PIA TÖRNELL UGLYCUTE
ANNA VON SCHEWEN

New Swedish Design

18 November 2004 – 6 February 2005
Crafts Council Gallery. Free Entry.

Crafts Council, 44a Pentonville Road, London N1 9BY
Tuesday to Saturday 11am – 6pm, Sunday 2 – 6pm
Shop and Resource Centre. Closed Monday.
Disabled Access. Three minutes from Angel Tube.
Telephone 020 7278 7700 www.craftscouncil.org.uk

Kerr|Noble's Crafts Council Beauty and Beast: *New Swedish Design* came from research into Swedish way of life, geology
& geography. The visual language was inspired by the idea of chopping wood and so axing into simple shapes to create letterform,
and applied to posters, exhibition invitations and print materials, and typeface creation.

Apollonio , U. *Futurist Manifestos* New York: Viking

Barthes, R. *The Third Meaning: Research Notes on Several Eisenstein Stills. The Responsibility of Forms: Critical Essays on Music, Art, and Representation.* Transl. Richard Howard. Berkeley: U of California

Barthes, R. *Method. The Fashion System.* Transl. Matthew Ward and Richard Howard. New York: Hill

Barthes, R. *Rhetoric of the Image. The Responsibility of Forms: Critical Essays on Music, Art and Representation.* Berger, J. *Ways of Seeing.* London: Penguin, 1972.

Bayley, S. *Taste* Boilerhouse Project

Baines, P. *Type and Typography*

Bernard, B. *Century* Phaidon

Bierut, M. *Looking Closer: Critical Writings on Graphic Design.* London: Allworth Press,.

Birdsall, D. *Notes on Book Design* Yale University Press

Blackwell, L. *20th Century Type* Laurence King

Blackwell, L *Brands of tomorrow* Laurence King

Bilz, S. *Type One* Die Gestalten Verlag, Berlin

Bowler, B. *The Word as Image.* London: Studio Vista.

Burt, C. *A psychological study of typography* Cambridge University Press.

Business Start Up Guide The Design Trust

Carter, R, Day, B, and Meggs, P. *Typographic Design: Form and Communication* Van Nostrand Reinhold, Chicago P, "Semiotics, Materiality and Typographic Practice," "Visual and Literary Materiality in Modern Art,"

Crary, J. Techniques of the Observer: On Vision and Modernity in the Nineteenth Century. Cambridge, MIT Press.

Crow D. *Visual Signs - An Introduction to Semiotics* Ava Publishing

Drucker, Johanna. The Visible Word: Experimental Typography and Modern Art Chicago: U of

Eco, U. *The Name of the Rose* Picador

Evans. H *Pictures on a page, the way things are* World Press

Fawcett-Tang, R. *New Book Design* Lawrence King

Fawcett-Tang, R. *Experimental Formats* Lawrence King

Fawcett-Tang R. *Mapping* Rotovision

Fletcher A. *The Art of Looking sideways* Phaidon Press

Foucault, M. *This is Not a Pipe.* Transl. James Harkness. Berkeley: U of California

Foucault, M. "Las Meninas." The Order of Things. New York: Random

Franks. R, *The Americans* Scalo Publishers

Frost, C. *Designing for Newspapers and Magazines* Routledge

Gatter, M *Software Essentials for Graphic Designers* Lawrence King

Gatter, M. *Getting it Right in Print: A Guide for Graphic Designers* Lawrence King

Godin, S. *Permission Marketing: Turning strangers into friends and friends into customers* Freepress

Hedgecoe J. *The New Manual to Photography* Dorling & Kindersley

Helfand, J. Screen: Essays on Graphic Design, New Media, and Visual Culture. Princeton Architectural Pr.

Hodnett, Edward. Image and Text: Studies in the Illustration of English Literature. London: Scolar Press

Hofstadter, D. *Metamagical Themes, Questing for the Essence of Mind and Pattern* Basic Books

Hollis, R. *Graphic Design – A Concise History* Thames and Hudson

Homung, D *COLOUR: A workshop for artists and designers* Lawrence King

Howes, D *Empire of the Senses* Berg

Hutton, W. *On the Edge: living with global capitalism* Vintage

Jones, J. C. *Design Methods* John Willey & Sons

Kalman, T. *Chairman* Lars Müller

Kane, J. (A *Type Primer* Laurence King

Kinross, R. *Modern Typography: An essay in critical history* Hyphen Press,

Klein, N. *Nologo* Rotovision

Koolhaas, R. *Small, Medium, Large, Extra Large.* 010 Publishers

Kusters, C., King, E. *Restart* Thames and Hudson

Landau, S *Dictionaries, The Art and Craft of Lexicography,* Simon & Schuster

reference

Lechte, J. Fifty *Contemporary Thinkers*. London and New York: Routledge

Lessig, Lawrence. *Free Culture: How Big Media Uses Technology and the Law to Lock Down Culture and Control Creativity*. New York: Penguin,

Lupton, E and J. Abbott Miller *Design Writing Research: Writing on Graphic Design*, Phaidon

Lupton, E. *Thinking with Type* Palgrave Macmillan

Massin *Letter and Image* Studio Vista London

Maeda, J. *maeda@media* Thames and Hudson

McLuhan M *Understanding Media* MIT Press

Mills, S *Discourse*. London: Routledge,

Kusters, C., King, E. Restart Thames and Hudson

Mitchell, W. J. T. "*Ekphrasis and the Other.*" *Picture Theory*. U of Chicago

Mollerup P. Marks of Excellence Phaidon Press

Monnery, S *The Writing on the Wall: Word and Image in Modern Art* Thames and Hudson

Muller-Brockmann, J. A *History of Visual Communication*. Switzerland: Verlag Arthur Niggli

Negroponte, N *Being Digital* Coronet

Norton, W *Complete Guide for Running a Graphic Design or Communications Business*

Odling-Smee, A. *Handmade Graphics* Rotovision

Pineda, V. "Speaking about Genre: The Case of Concrete Poetry."New Literary History 26: 379-93.

Pipes, A. *Production for Graphic Designers* Laurence King Publishing

Poyner P. Crowley, D. *Communicate* Laurence King

Powell, M. *Presenting in English:* Language and teaching publications

Pogue, D. *Imovie/IDVD 5 the missing manual* O'Reilly UK

Rand, P. *A Designers Art*. New Haven: Yale: University Press

Rand, P. *Design, Form and Chaos*. New Haven: Yale: University Press

Roberts, L. *The designer and the Grid* Rotovision

Saarinen, E. Taylor, M. *Imagologies* Routledge

Samara, T. *Making and breaking the Grid* Rockport

Selgado. S. *Workers* Phaidon

Shaughnessy A. *How to be a graphic designer without losing your soul* Laurence King Publishing

Shaw, Mary Lewis. "Concrete and Abstract Poetry: The World as Text and the Text as World." *Visible Language*

Speikerman, E. *Stop Stealing Sheep* Adobe Press

Spencer, H. *Pioneers of modern typography*. London: Hastings House.

Staal, G. *Koeweiden Postma: New Dutch Design* Book Industry Services

Stammers, J. *Panoramic Lounge* Poetry Society

Tarkovskii, A. *Sculpting In Time: Reflections on Cinema* University of Texas Press

Tinker, M.A. *Legibility of Print*, 3rd edition. Iowa: Iowa State University Press

Tschichold, J *The New Typography*. (English Translation) California: University Of California Press

Tschichold, J. *Asymmetrical Typography*. London: Reinhold Publishing

Tufte. E, *Envisioning information* Graphics Press

Tufte, E. *Visual Explanations: Images and Quantities, Evidence and Narrative*. Graphics Press.

Viscomi, J. *Blake and the Idea of the Book*. Princeton UP

Wilk, C. *Modernism - Designing a New World 1914 - 1939* V&A Publications

Winchester, S *The Professor and the Madman, A Tale of Murder, Insanity, and the Making of the Oxford English Dictionary*

Hustwit, G. (2007) *Helvetica* Film

www.a-g-i.org/

www.aiga.org/

www.adobe.com

www.quark.com

index